Michelangelo/Titian

HARCOURT BRACE JOVANOVICH MASTERS OF ART SERIES

Harcourt Brace Jovanovich, Inc. New York

Text and design by the staff of Tokyo International Publishers, Ltd.

Copyright © 1967 by Kawade Shobō and The Zauho Press
English translation copyright © 1971 by Tokyo International Publishers, Ltd.

ISBN 0–15–159350–7
Library of Congress Catalog Card Number: 73–161099
Printed in Japan

CONTENTS

Photographed by

Scala-Orion (plate 1, 2, 3, 4, 5, 6, 7, 8, 10, 12, 17, 18, 19, 20, 21, 23, 31, 73, 75) Photographie Giraudon (9, 26, 30, 32, 41, 43, 44, 52, 64, 66, 71, 74) Hans Hinz SWB (13, 16, 24, 34, 36, 45, 49, 57, 63, 70) André Held (14, 15, 22, 25, 29, 33, 35, 37, 38, 39, 40, 42, 46, 47, 48, 50, 51, 53, 54, 55, 56, 58, 59, 60, 61, 62, 65, 67, 68, 69, 72) Staatliche Kunstsammlungen Dresden (28) Zauho Press (11, 27)

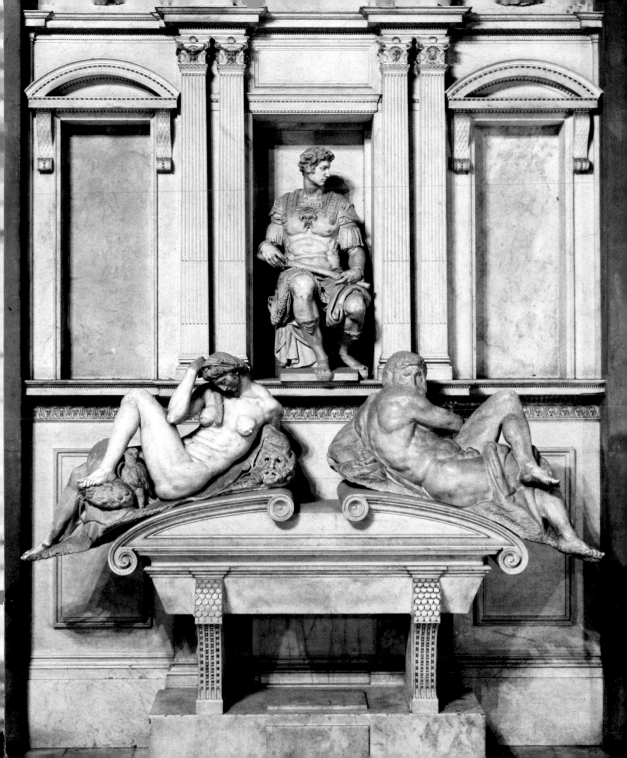

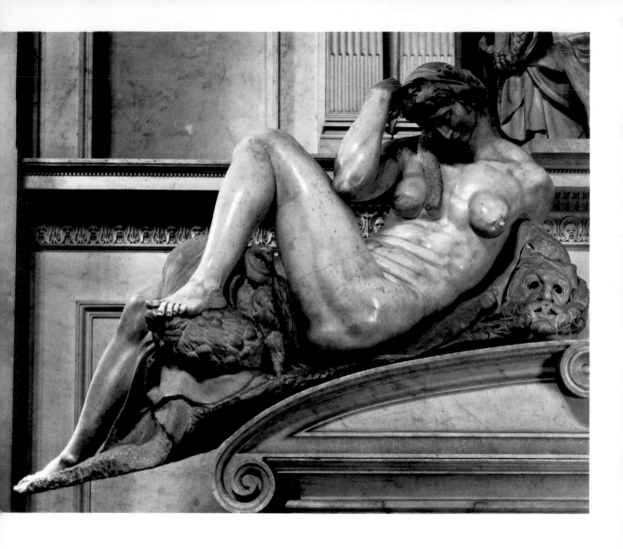

3 Michelangelo *Night*

2 Overleaf: Michelangelo *Tomb of Giuliano de' Medici* 1520–1534

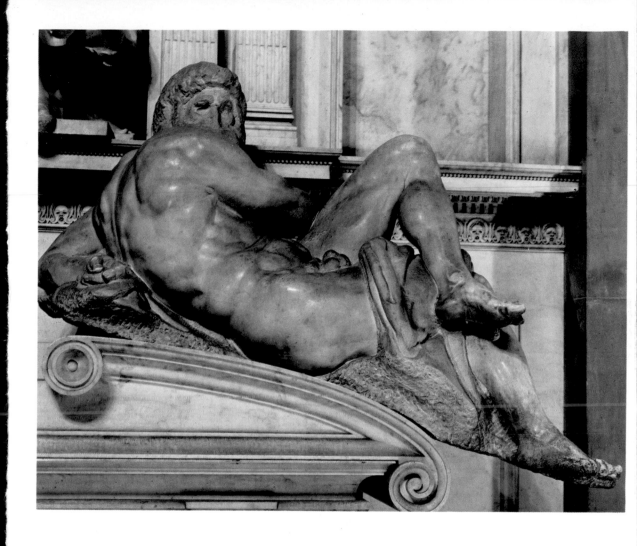

4 Michelangelo - *Day*

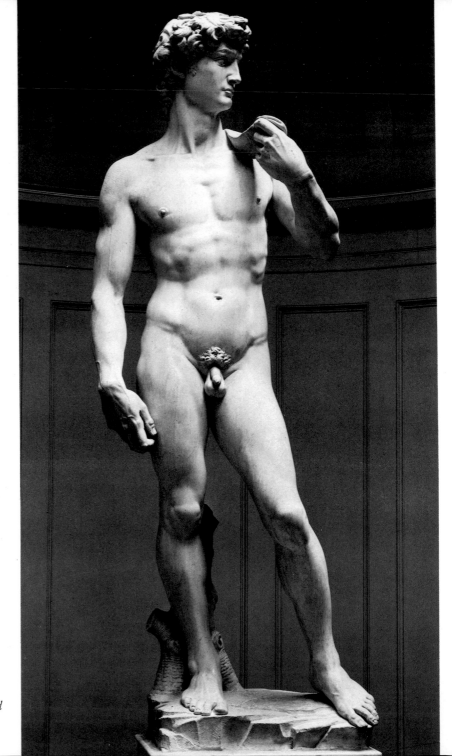

1
Michelangelo *David*
1501–1504

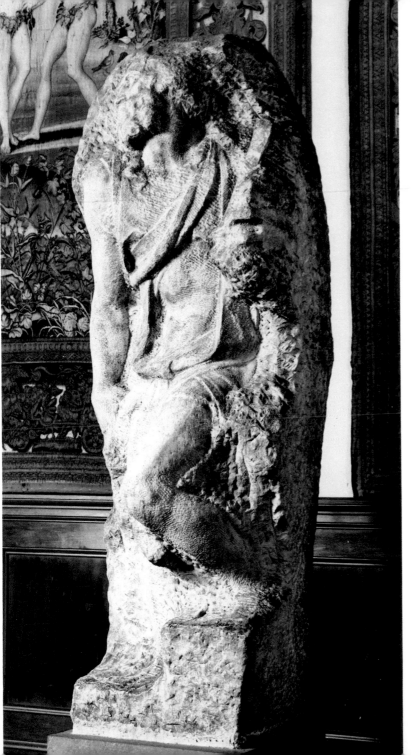

8
Michelangelo *Saint Matthew*
Circa 1501–1506

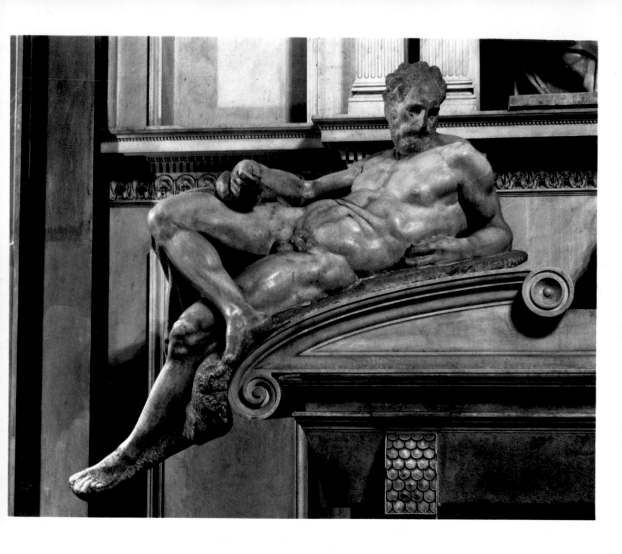

6 Michelangelo *Dusk*

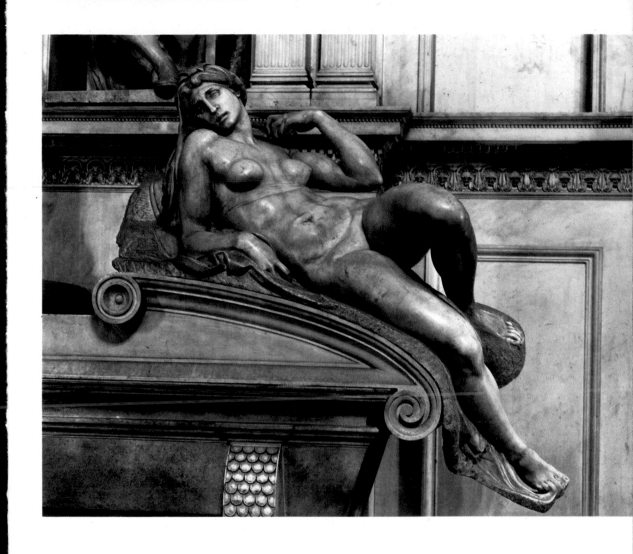

7 Michelangelo *Dawn*

5 Overleaf: Michelangelo *Tomb of Lorenzo de' Medici* 1520–1534

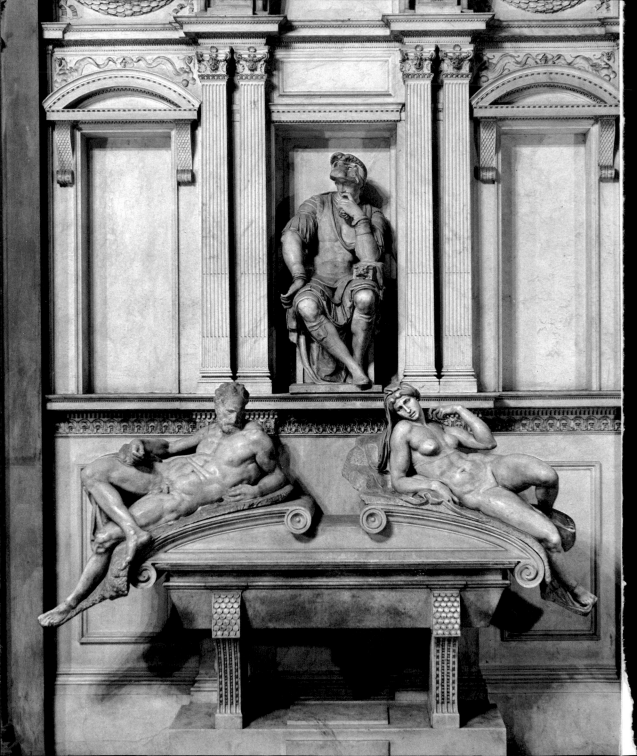

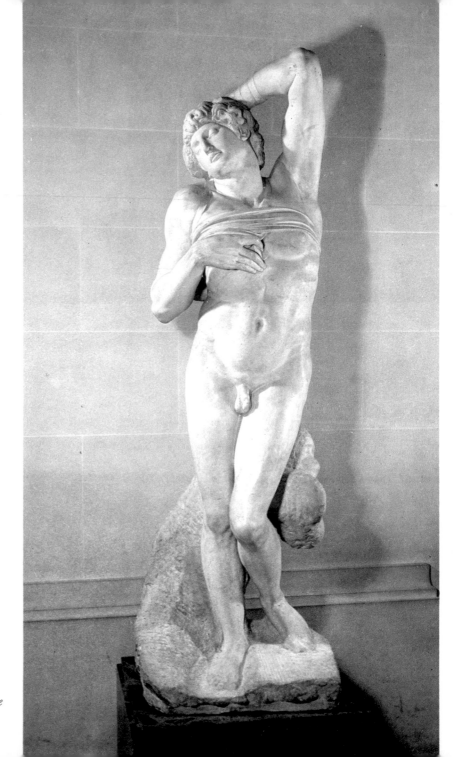

9
Michelangelo *Dying Captive*
1513–1516

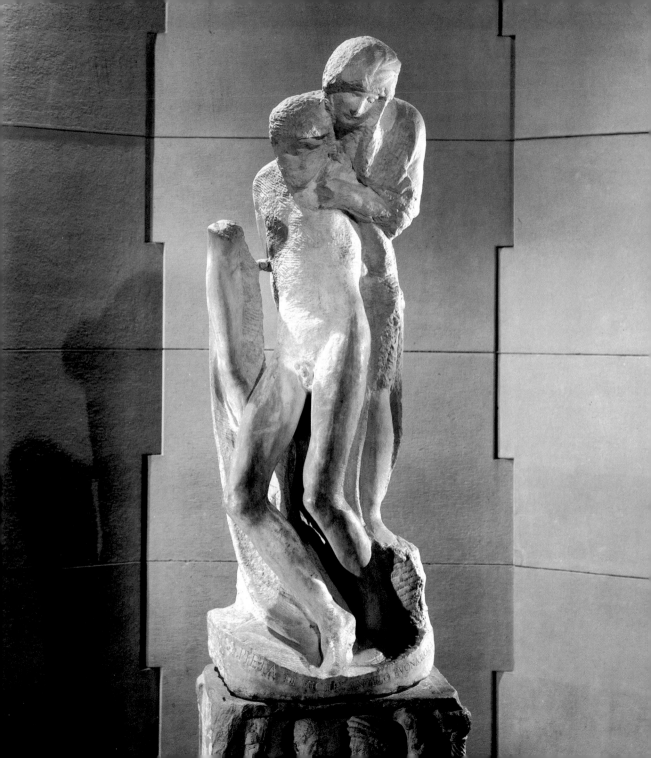

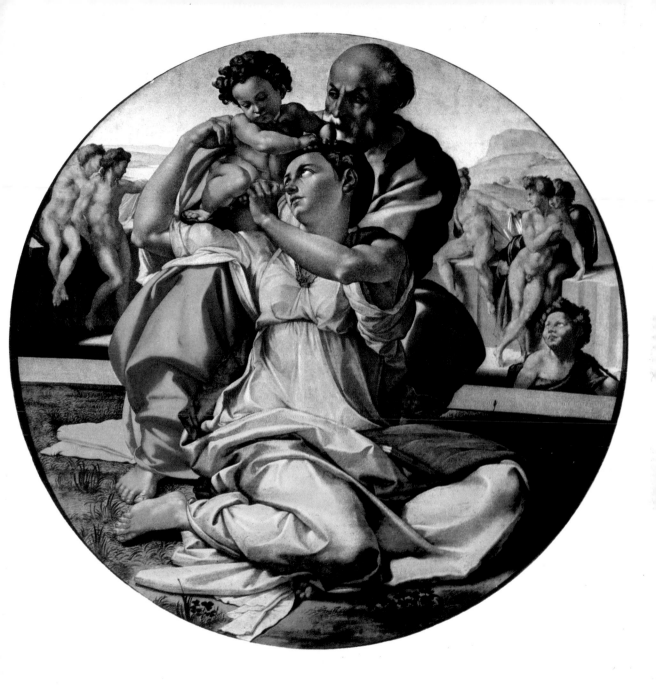

11 Michelangelo *Doni Tondo* 1504

10 Michelangelo *Rondanini Pietà* 1555–1564

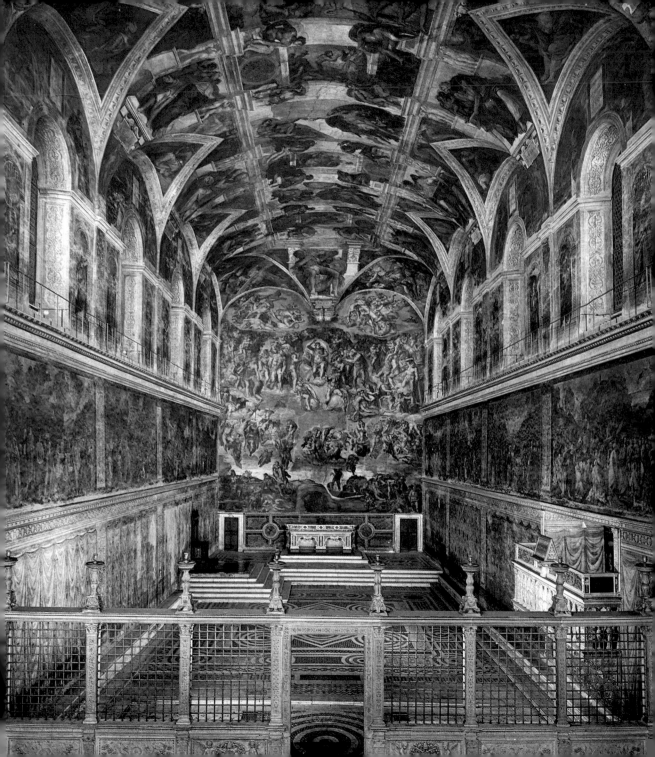

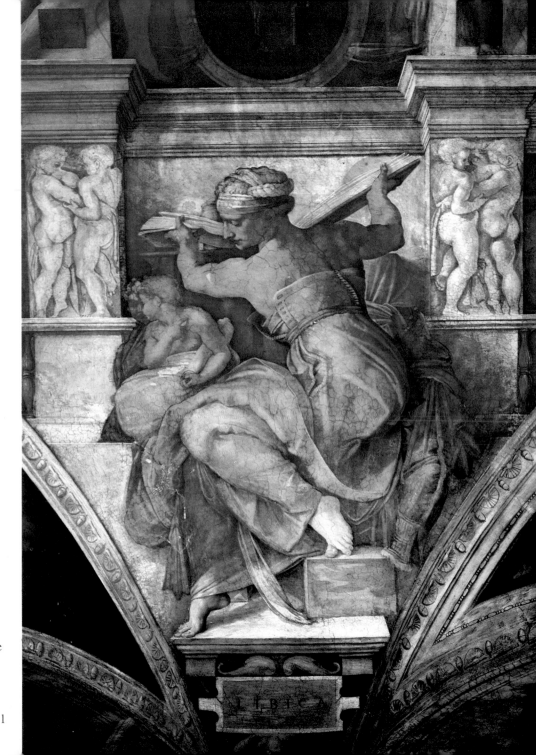

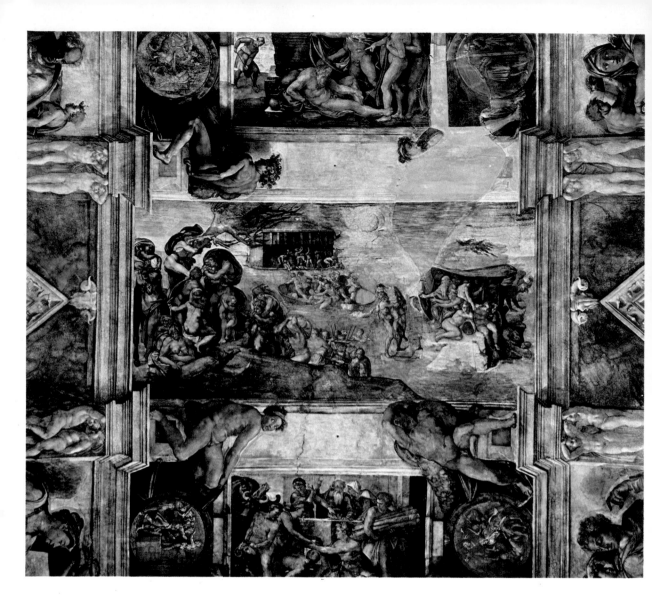

14 Michelangelo *Deluge* 1509

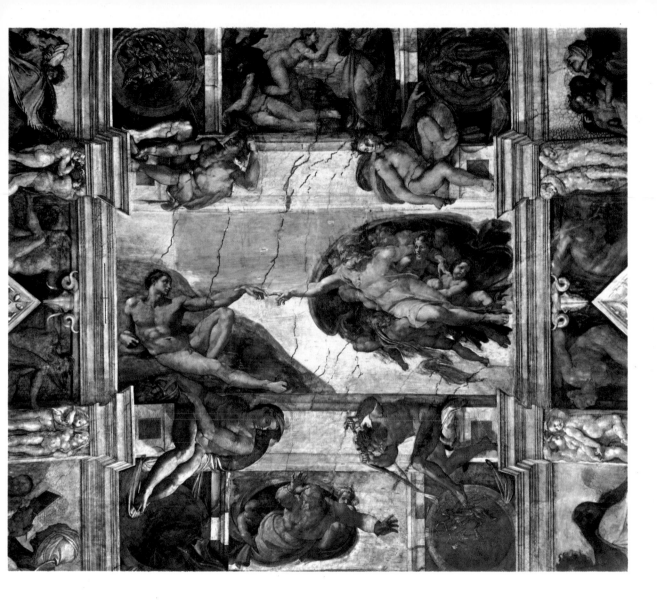

15 Michelangelo *The Creation of Adam*

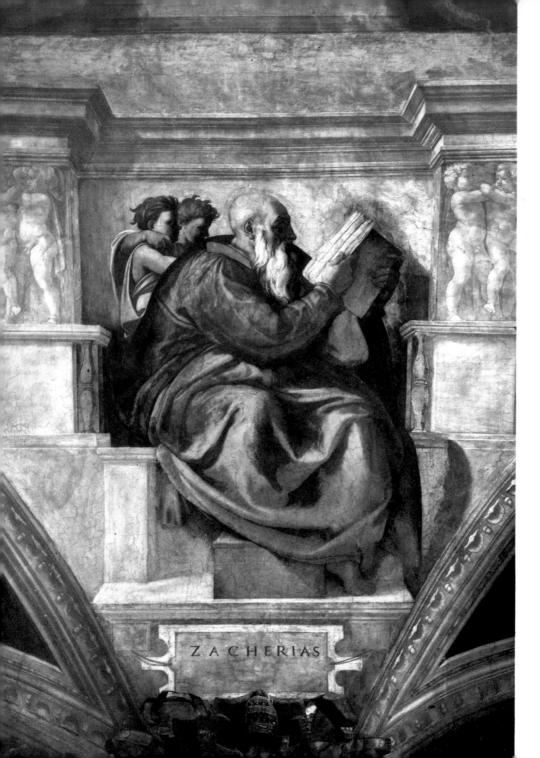

ZACHERIAS

16
Michelangelo
Zechariah

17
Michelangelo
Frescoes of the
Sistine Chapel
ceiling 1508–
1512→

18
Overleaf:
Michelangelo
*The Last
Judgment*
1536–1541→

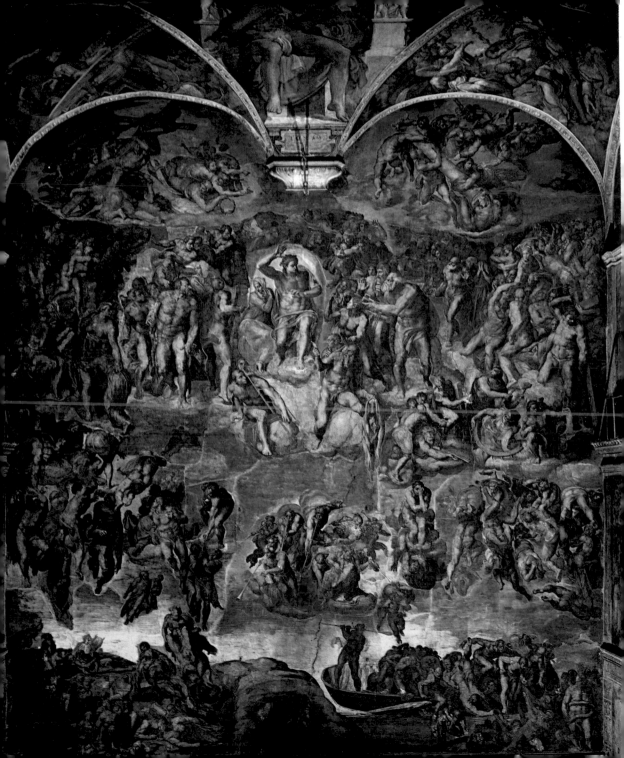

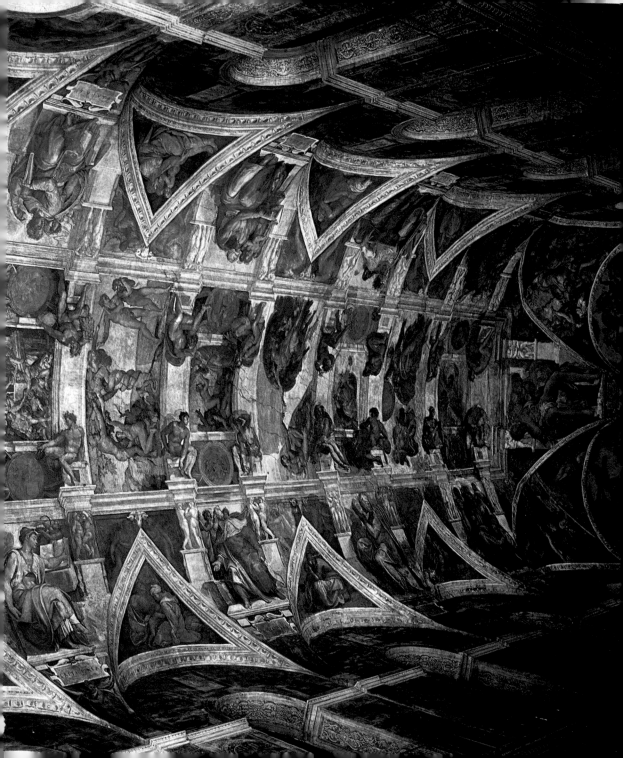

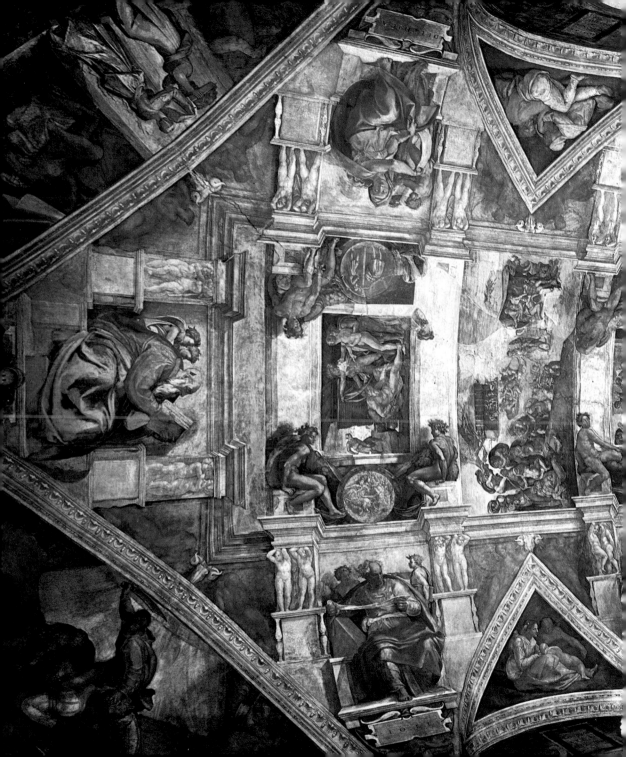

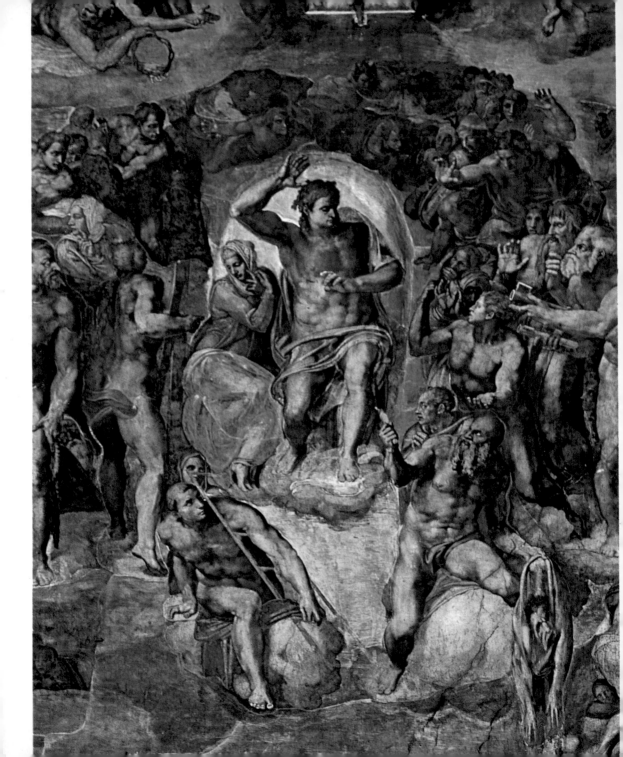

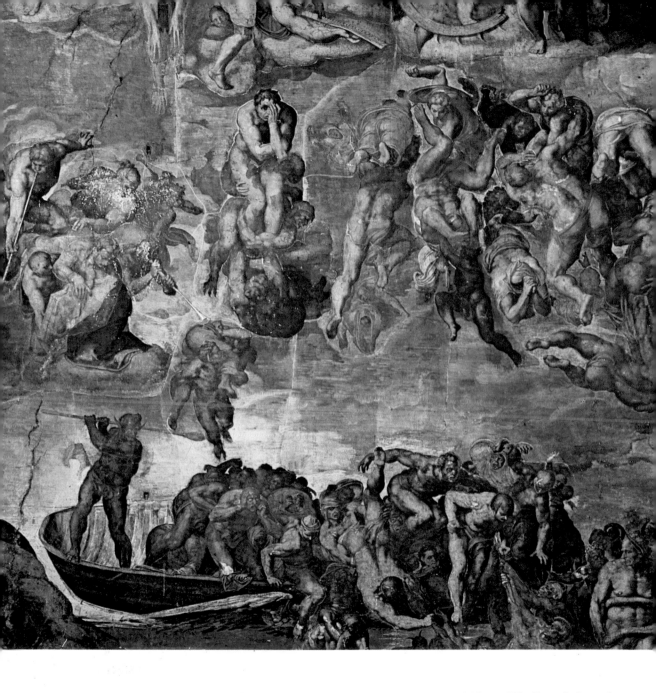

20 Michelangelo *The Damned* (from *The Last Judgment*)

←19 Michelangelo *Christ as Judge* (from *The Last Judgment*)

21
Giorgione
*Castelfranco
Madonna
Circa* 1500

22
Giorgione
*The Tempest
Circa* 1505–
1508→

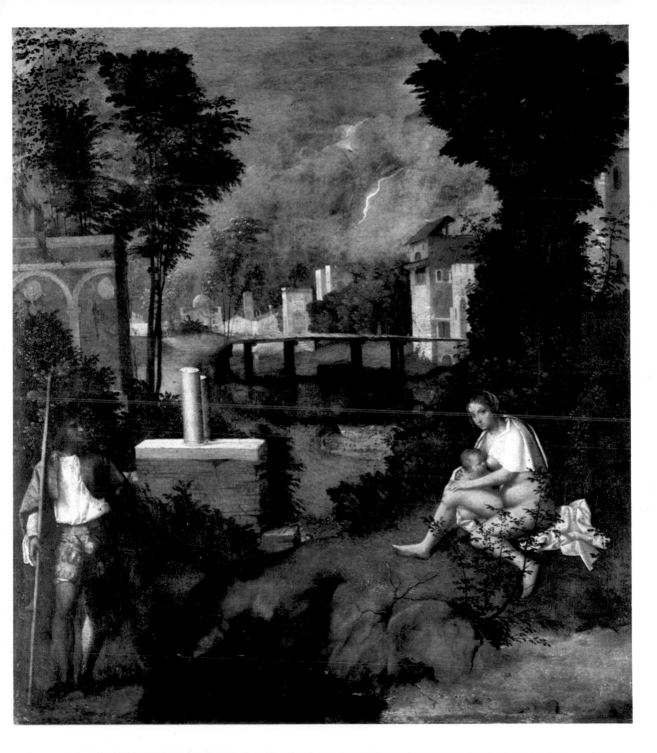

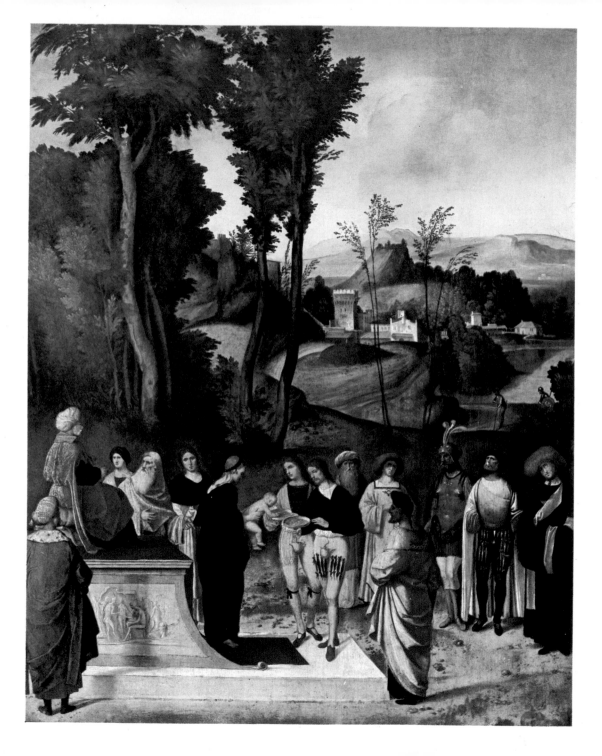

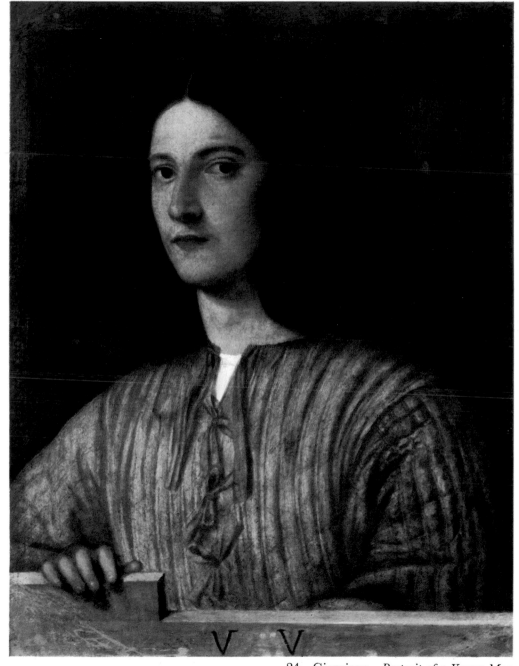

24 Giorgione *Portrait of a Young Man*

23 Giorgione *The Infant Moses before Pharaoh for the Trial of Gold and Fire*

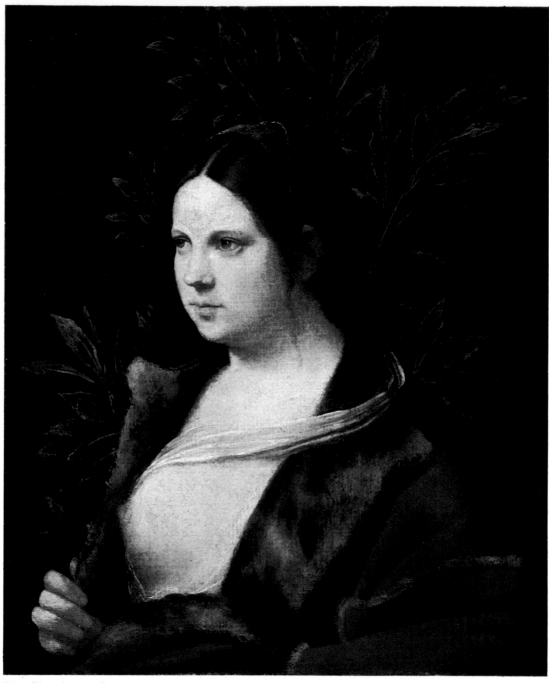

25 Giorgione *Laura*

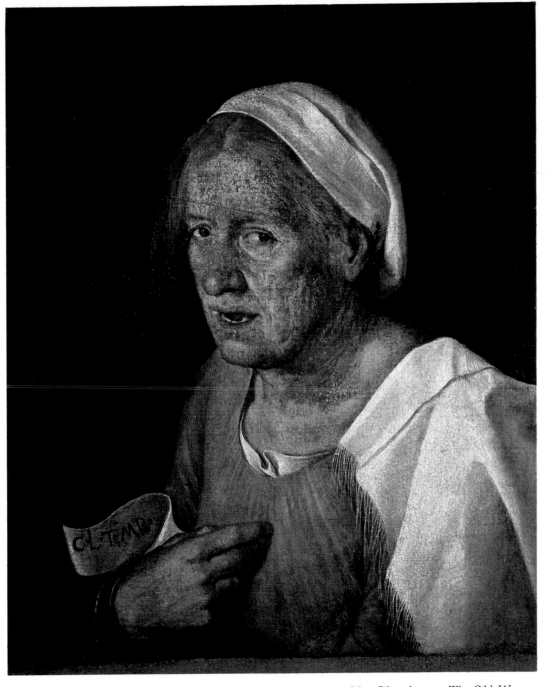

26 Giorgione *The Old Woman*

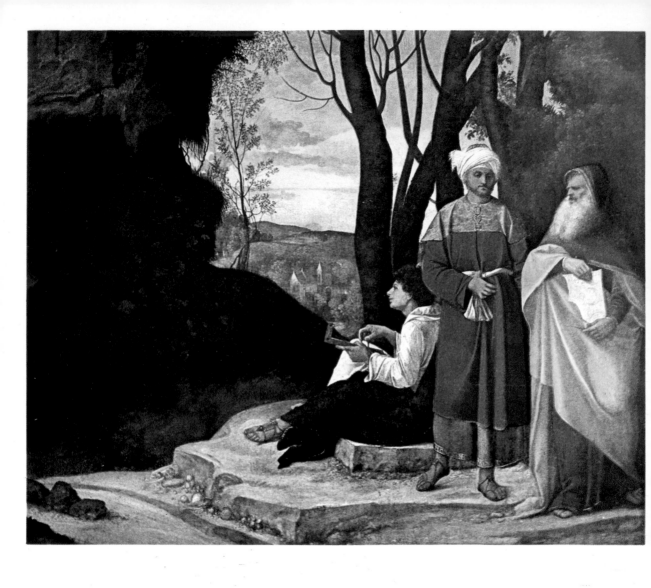

27 Giorgione *The Three Philosophers* *Circa* 1506–1508

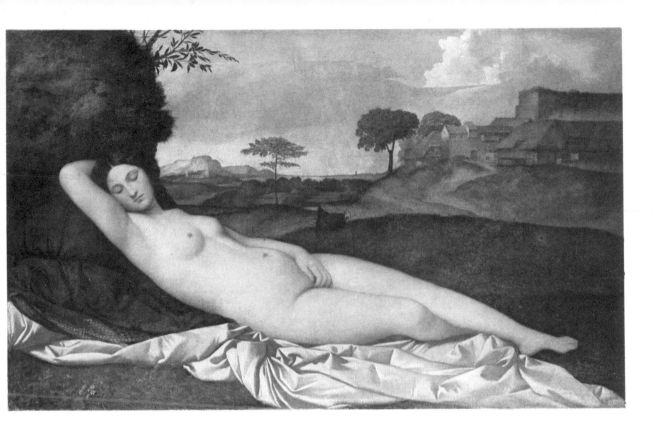

28 Giorgione *Sleeping Venus* 1508?

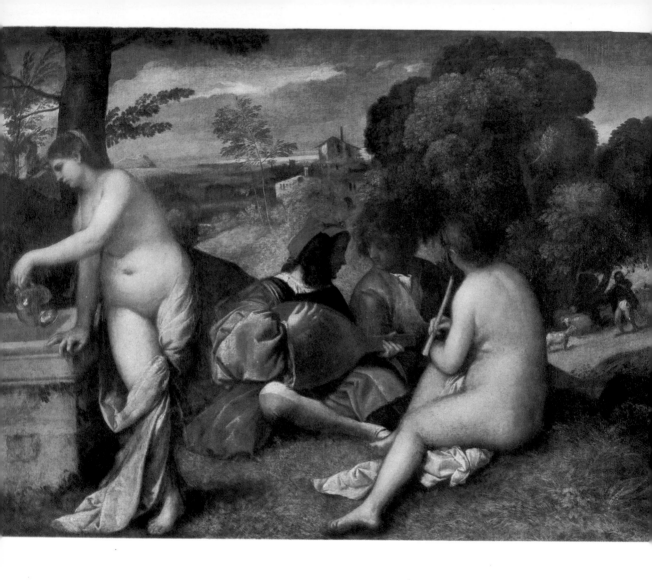

29 Giorgione and Titian *Fête Champêtre* *Circa* 1505–1510

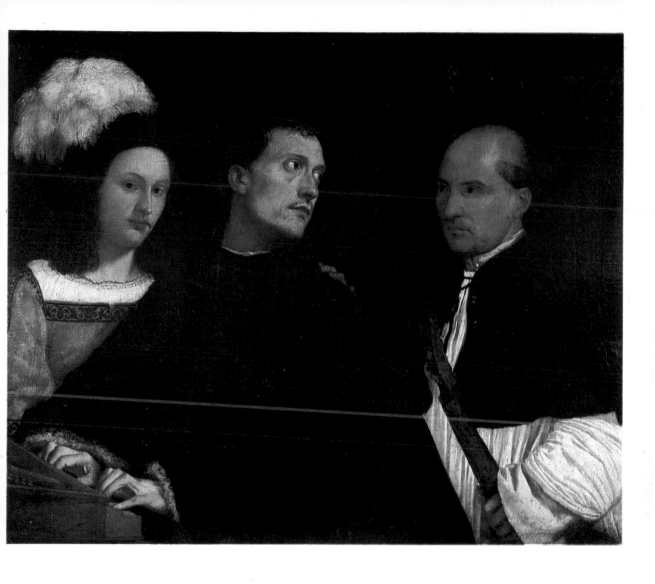

30 Giorgione and Titian *The Concert* *Circa* 1515

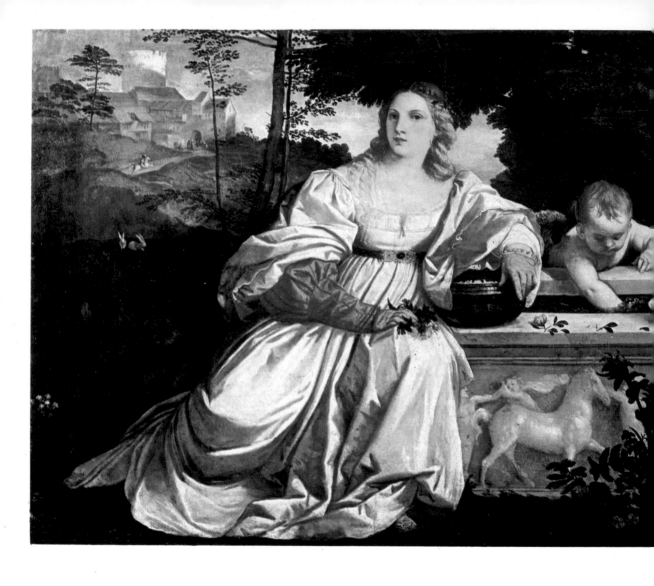

31 Titian *Sacred and Profane Love* *Circa* 1515

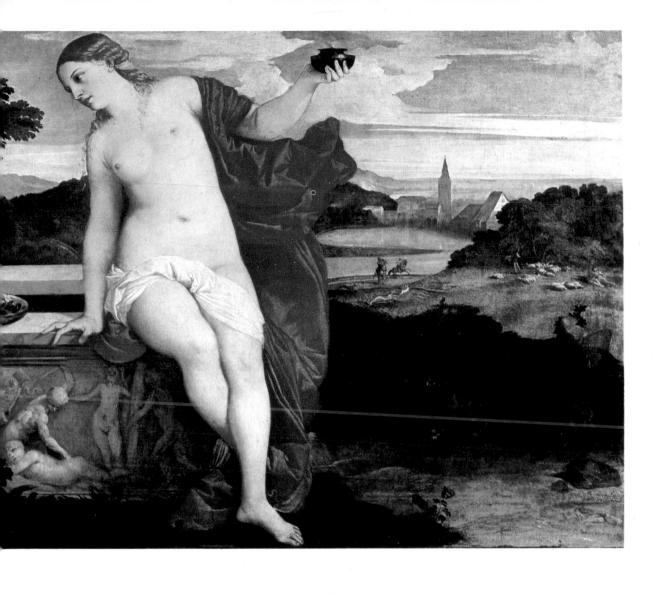

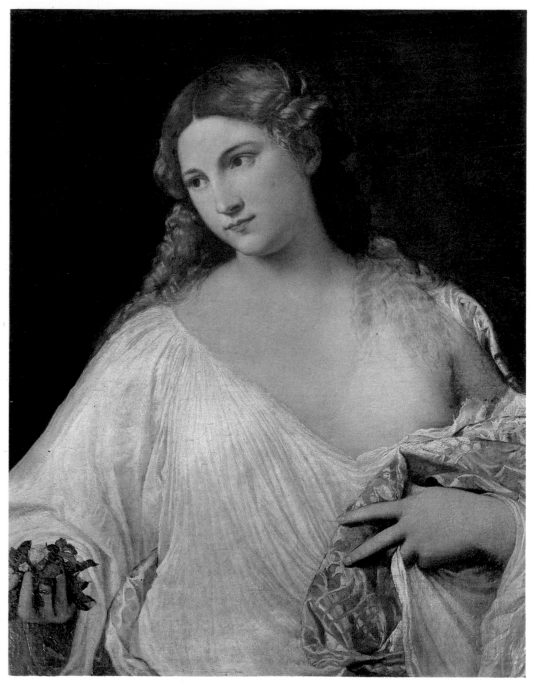

32 Titian *Flora* *Circa* 1515

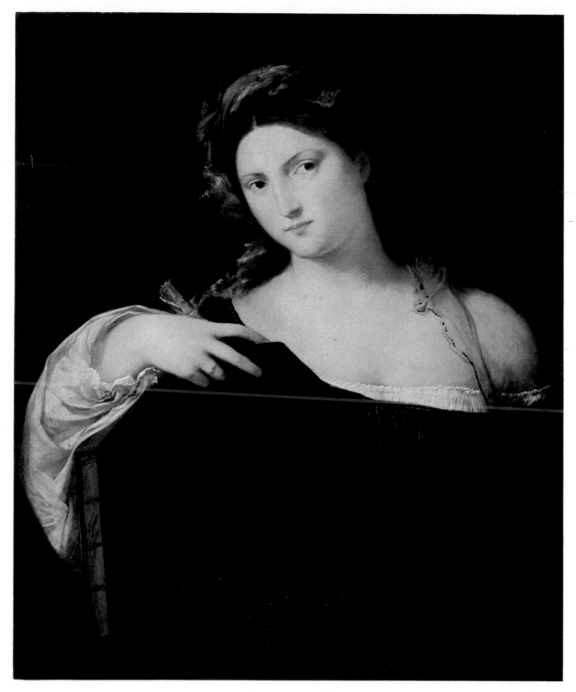

33 Titian *Vanity*

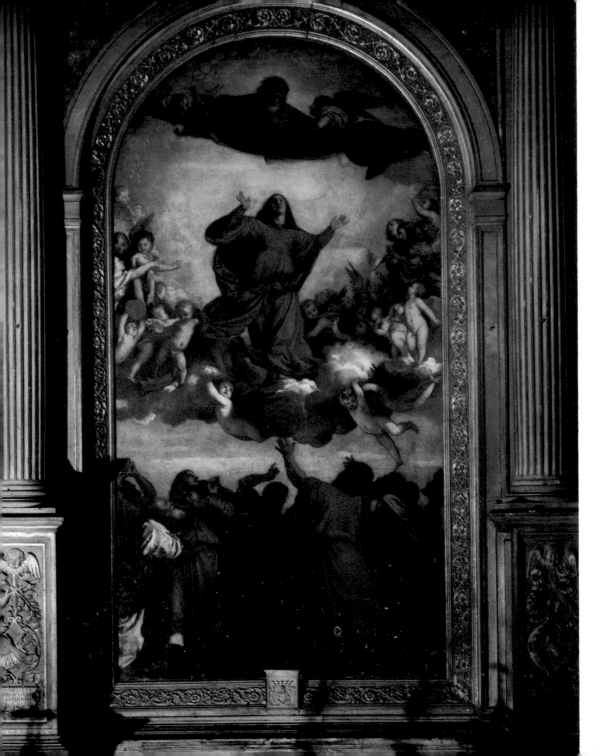

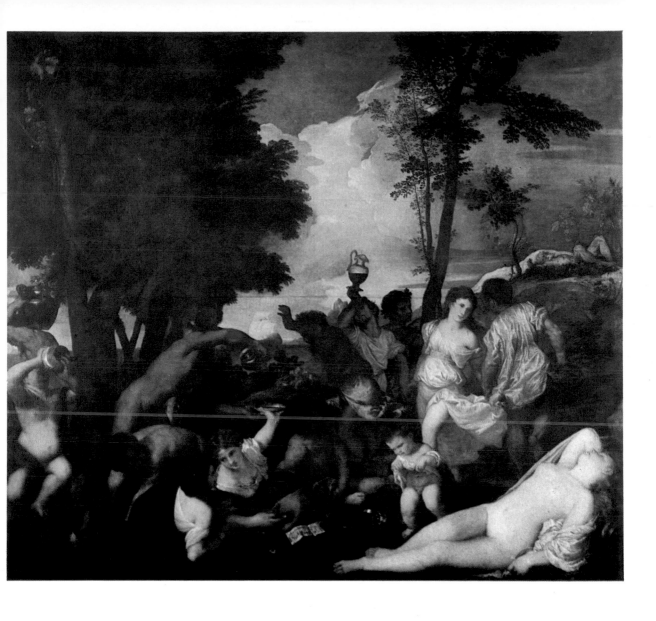

35 Titian *Bacchanal of the Andrians* 1518–1519

–34 Titian *Assumption of the Virgin* 1518

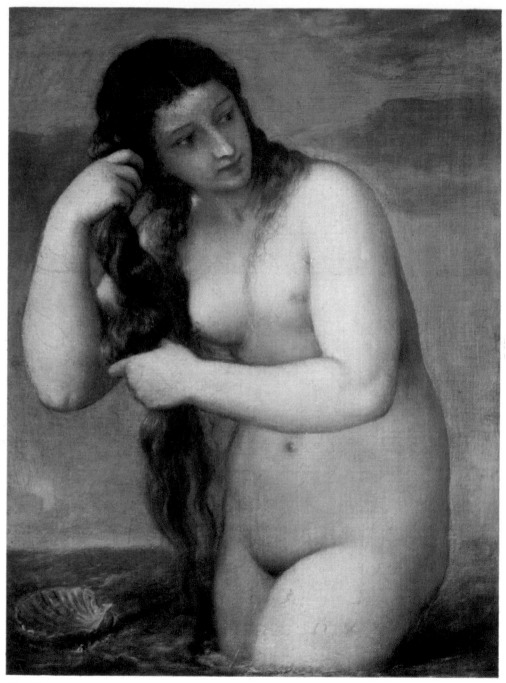

36 Titian *The Birth of Venus* 1517 or 1520

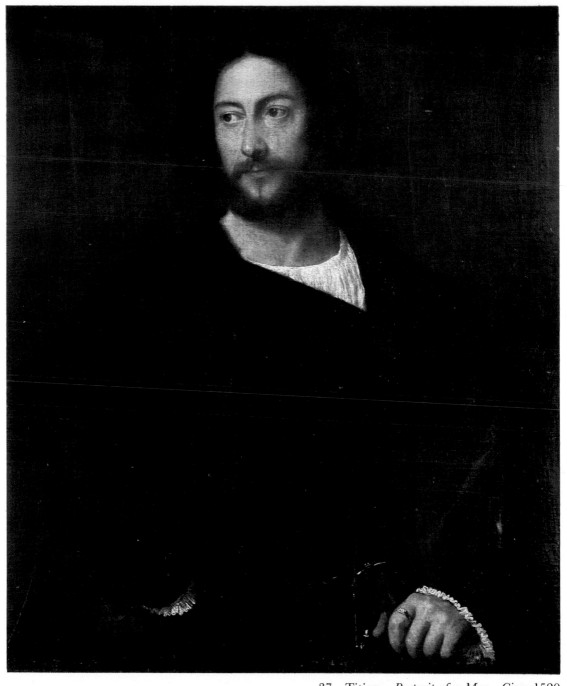

37　Titian　*Portrait of a Man*　*Circa* 1520

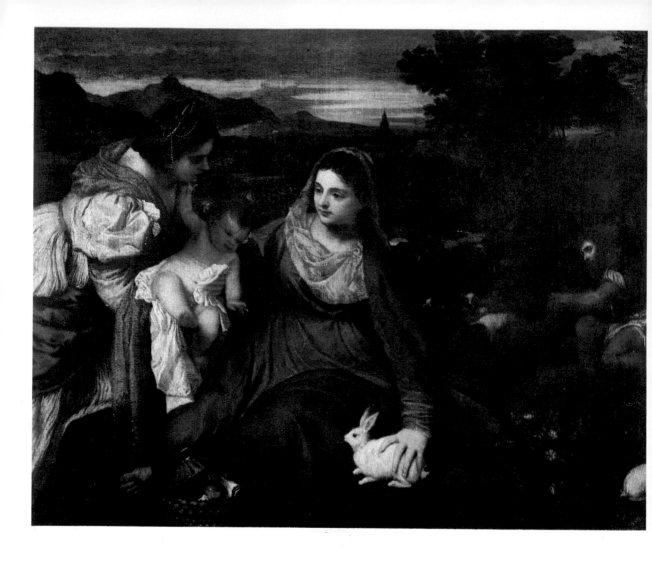

38 Titian *Madonna with the Rabbit* 1530

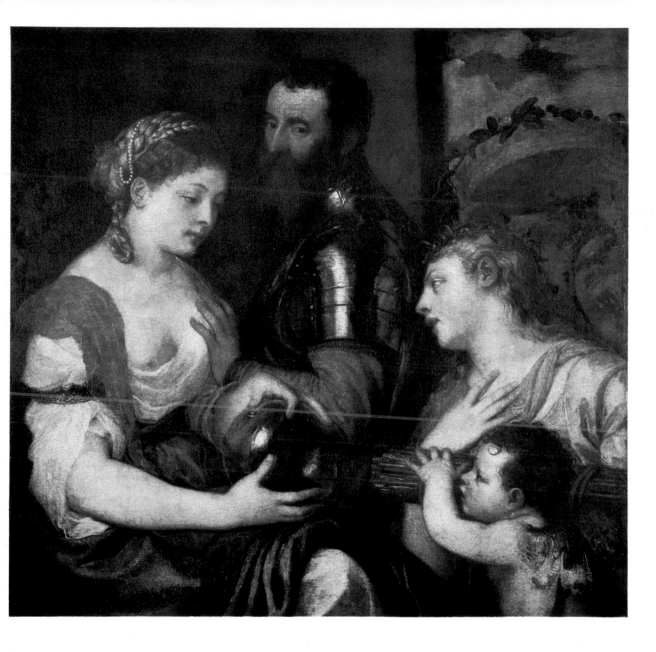

39 Titian *Allegory*

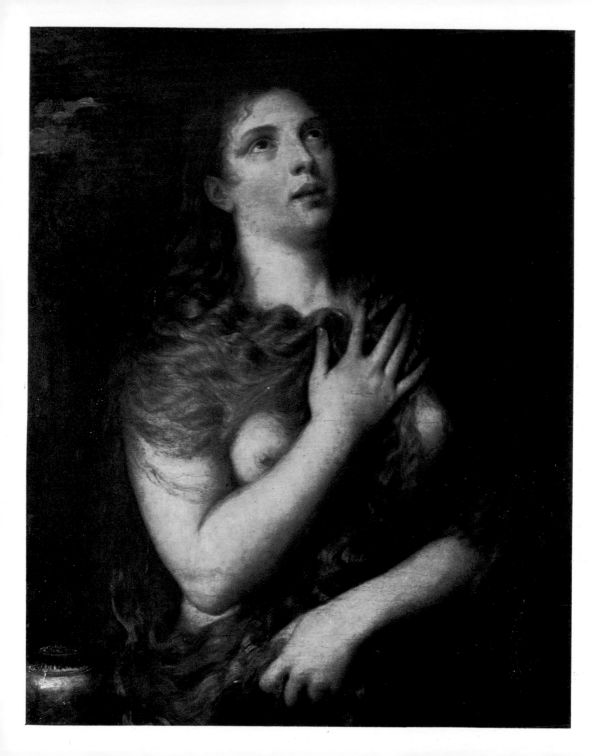

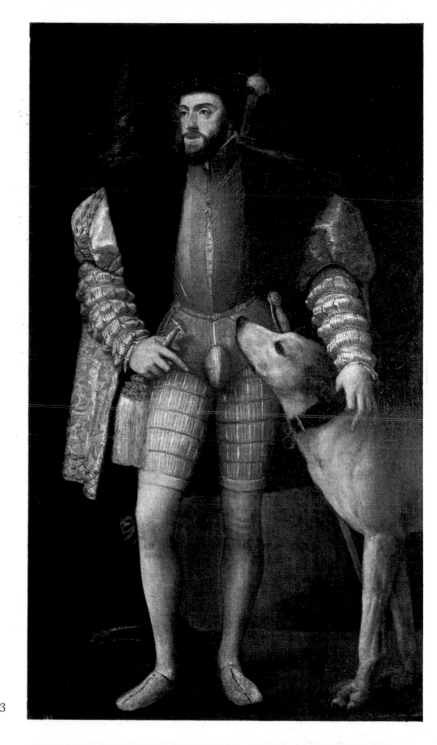

—40
Titian *Saint Mary Magdalen*
Circa 1533

41
Titian *Portrait of the Emperor*
Charles V with His Dog 1532–1533

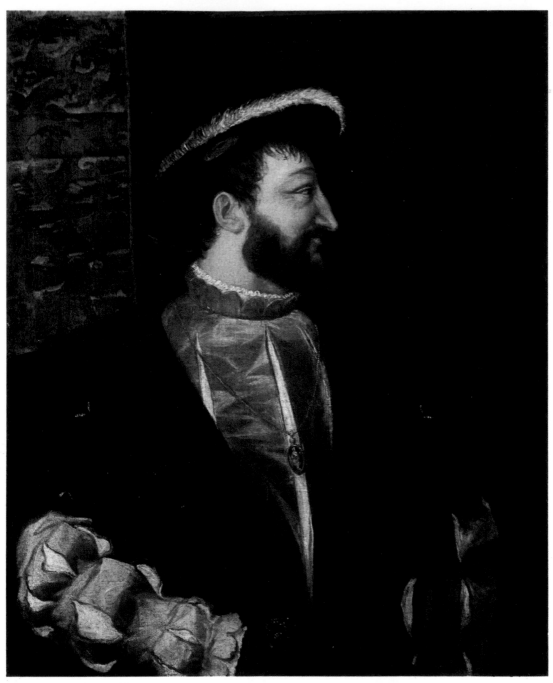

42 Titian *Portrait of Francis I*

43 Titian *La Bella* *Circa* 1536

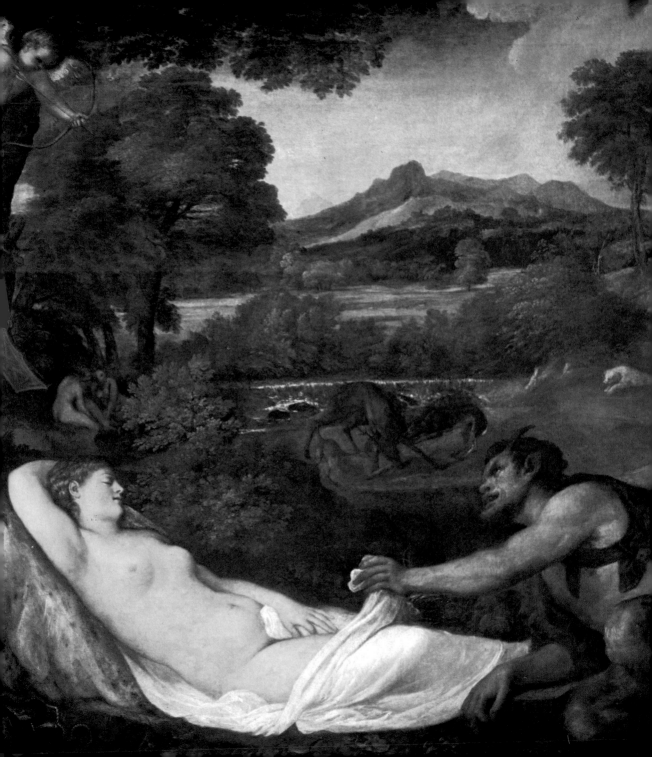

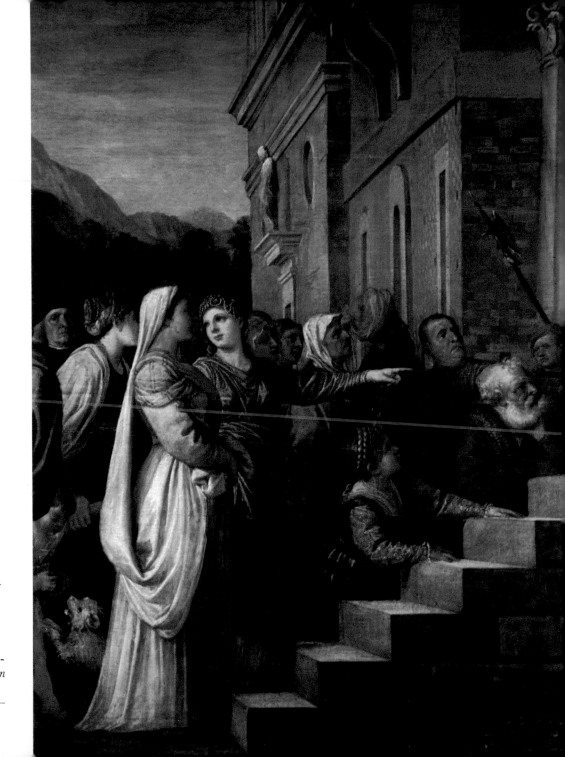

44
Titian *Jupiter
and Antiope*
(detail)

45
Titian *Presen-
tation of the Virgin
in the Temple*
(detail) 1534–
1538

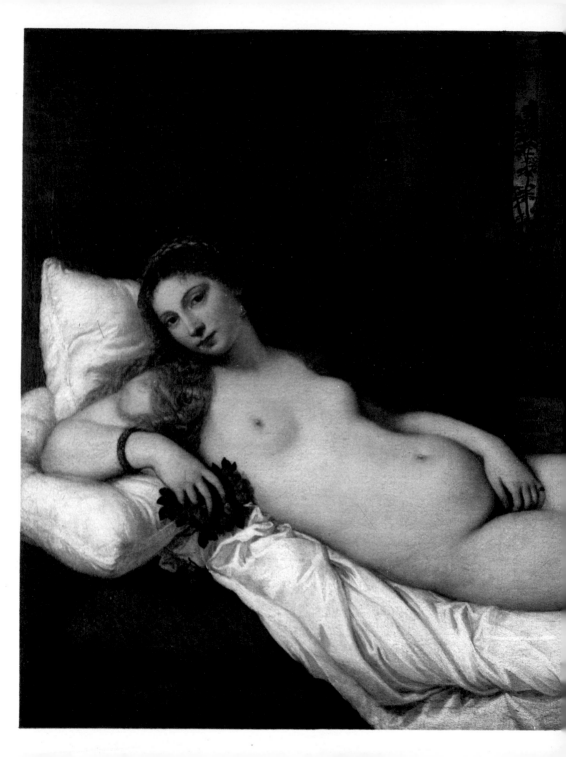

46 Titian *Venus of Urbino* *Circa* 1538

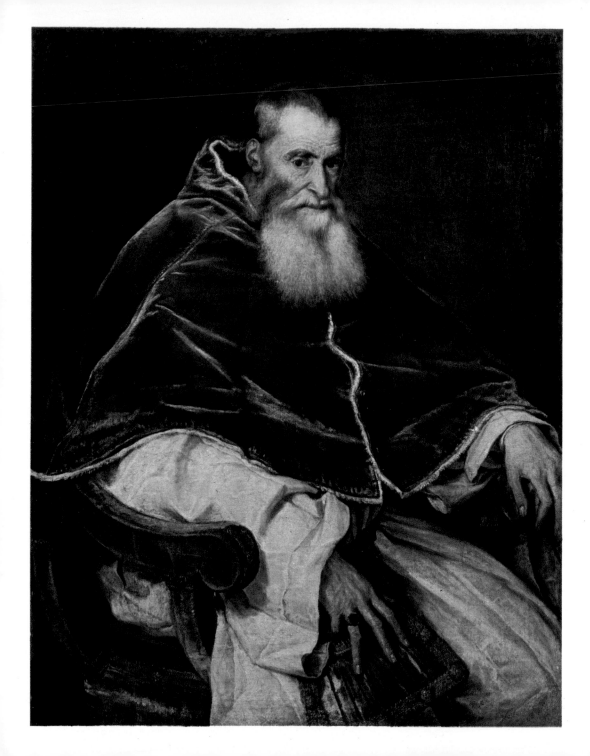

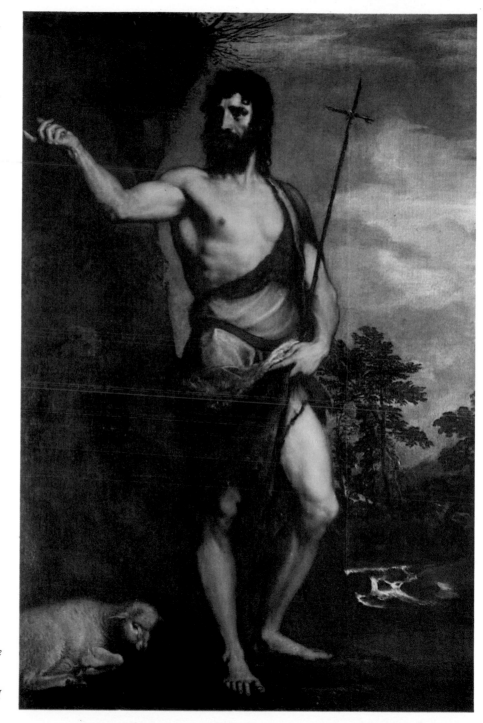

48
Titian *Saint John the
Baptist Circa* 1540

47 Titian *Pope Paul III*

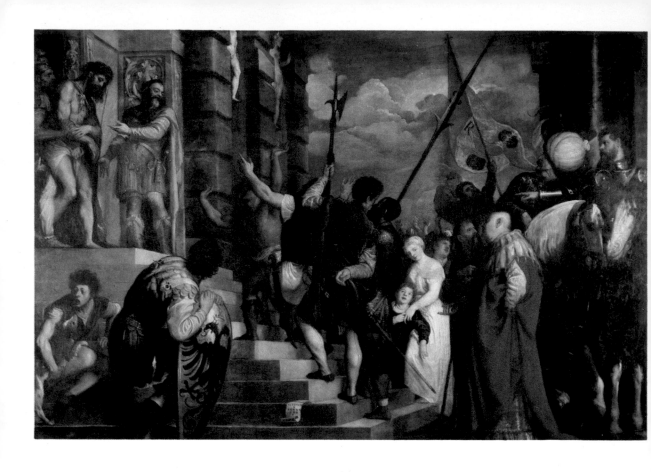

49 Titian *Ecce Homo* 1543

50 Titian *Portrait of a Man→*

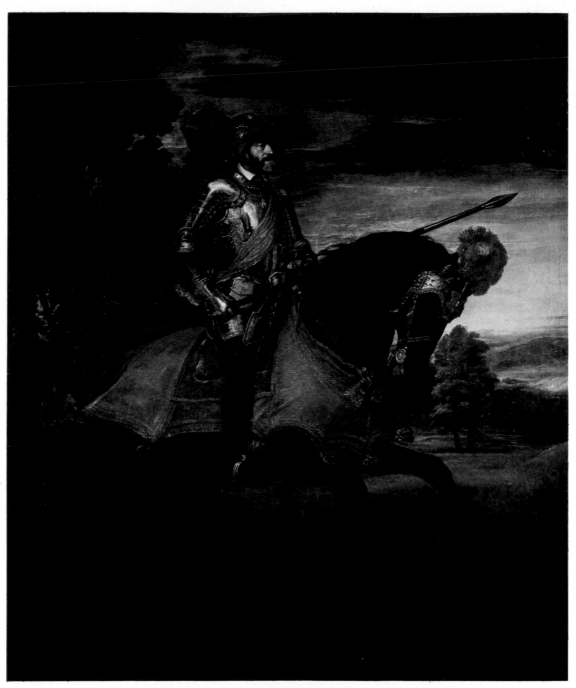

51 Titian *Portrait of Charles V at the Battle of Mühlberg* 1548

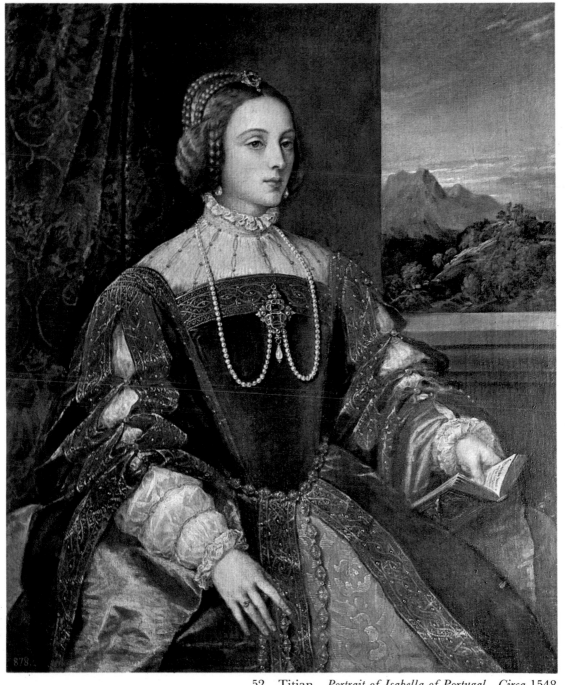

52 Titian *Portrait of Isabella of Portugal* *Circa* 1548

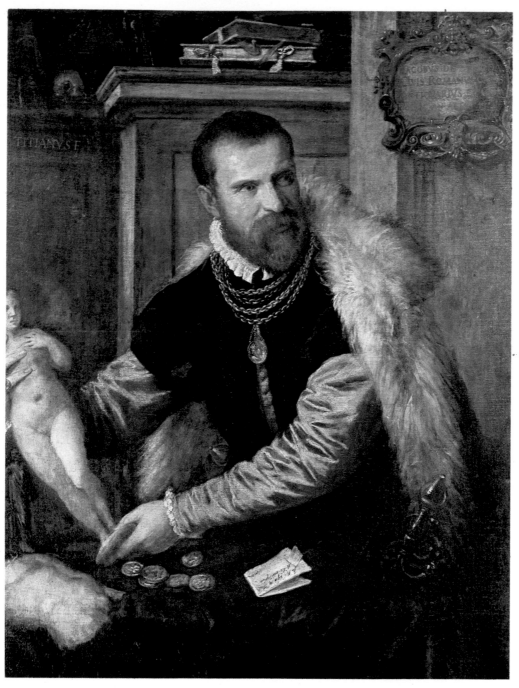

53 Titian *Portrait of Jacopo Strada* 1567–1568

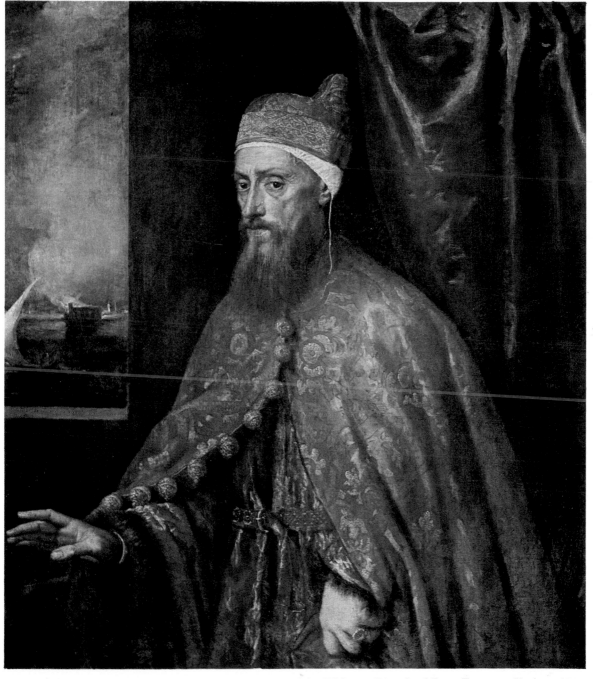

54 Titian *Portrait of Doge Francesco Venier* 1555

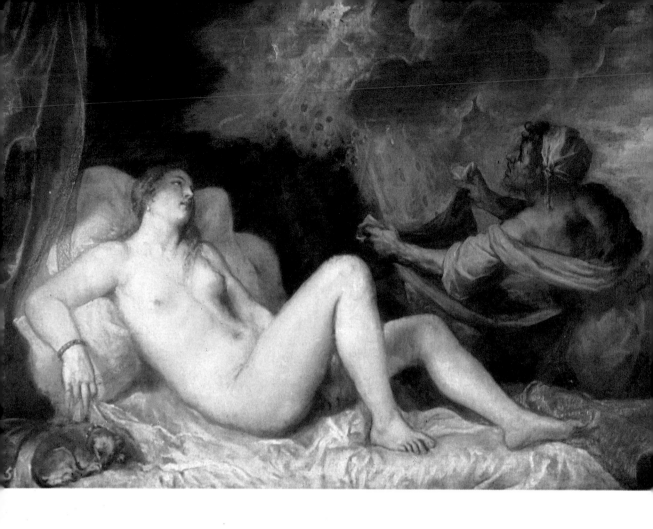

55 Titian *Danaë* 1553

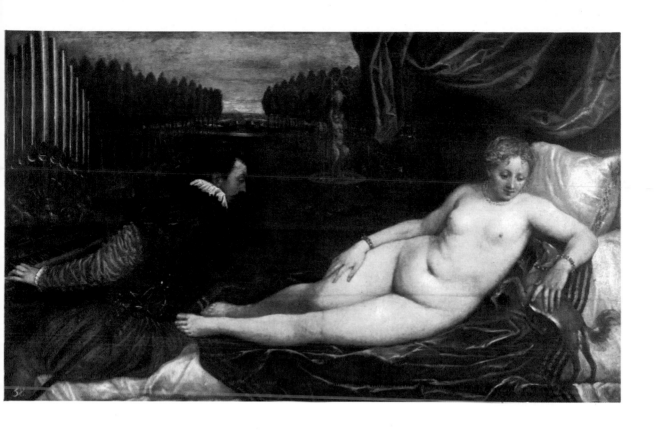

56 Titian *Venus and the Organ Player* *Circa* 1545

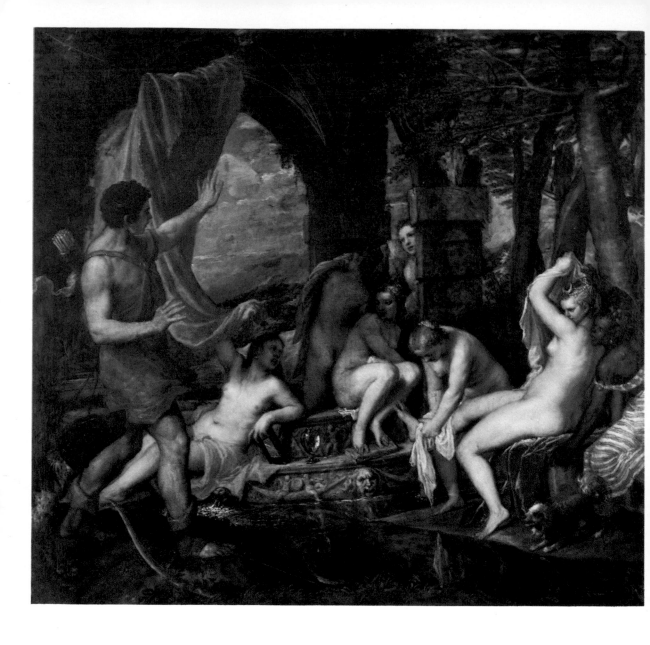

57 Titian *Diana and Actaeon* 1556–1559?

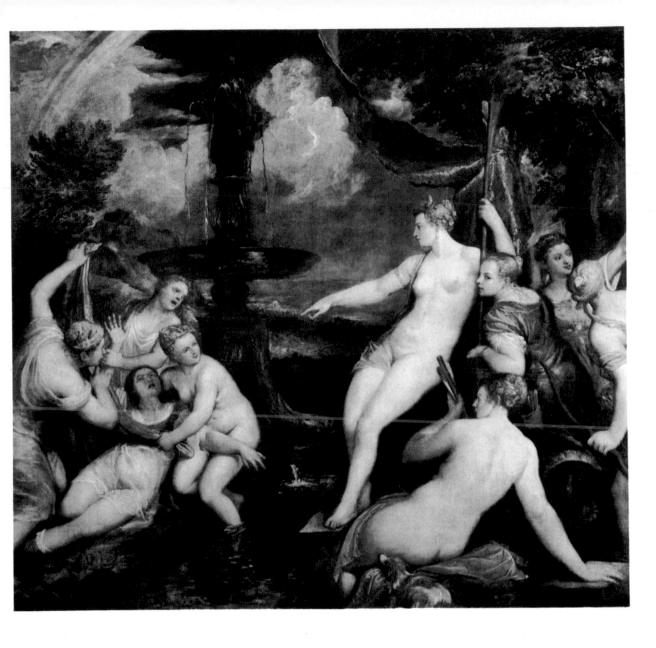

58　Titian　*Diana and Callisto*　1559–1562?

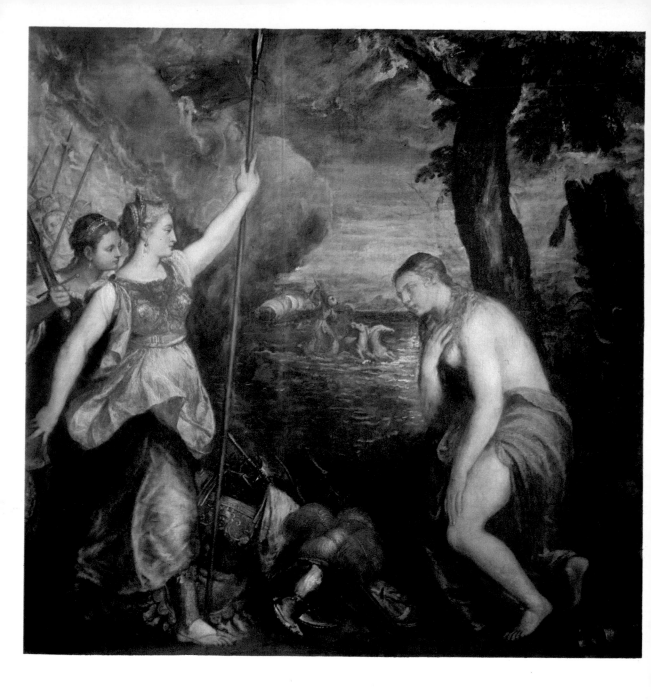

59 Titian *Religion Succored by Spain*

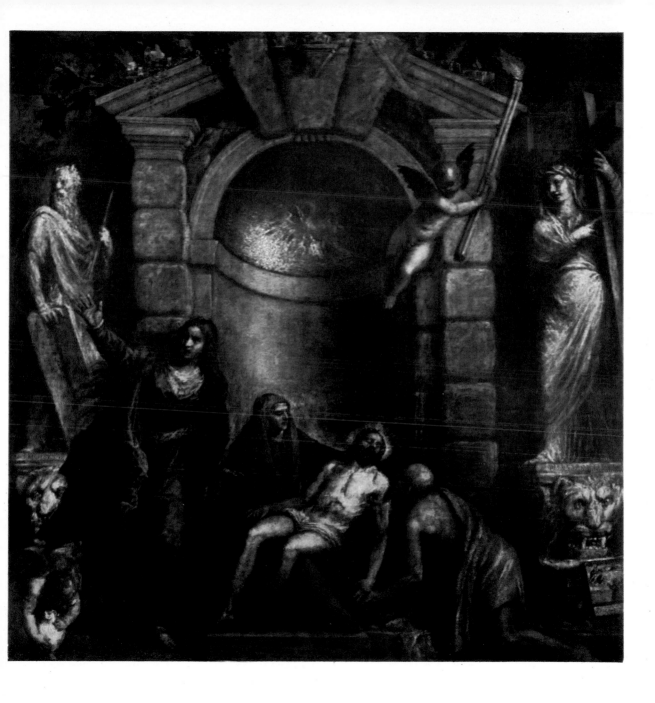

60 Titian *Pietà* 1575?

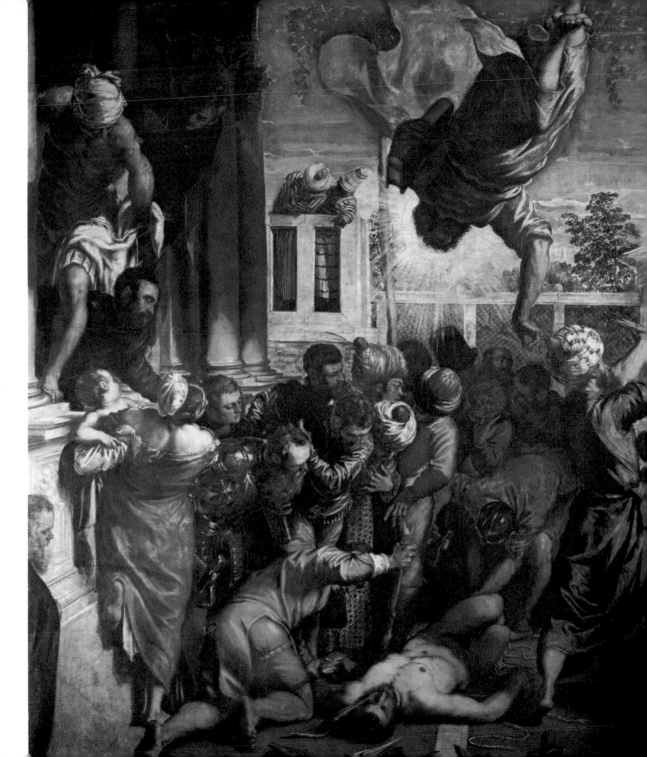

61
Tintoretto *Saint Mark Rescuing a Slave* 1548

62　Tintoretto　*Christ and the Adultress*　1545

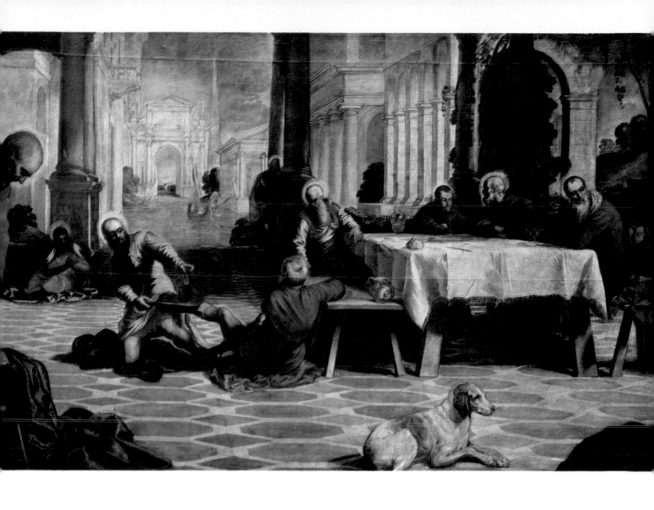

63 Tintoretto *Christ Washing the Feet of the Apostles* (detail) 1545–1547

65 Tintoretto *Adam and Eve* 1550–1551

64 Tintoretto *The Creation of the Animals* (detail) 1550–1551

66 Tintoretto *Susanna at Her Toilet* 1555–1560

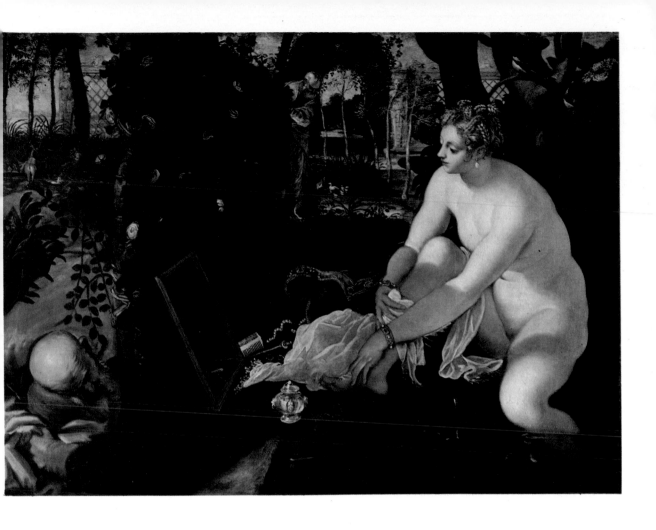

67 Tintoretto *Susanna and the Elders* *Circa* 1560

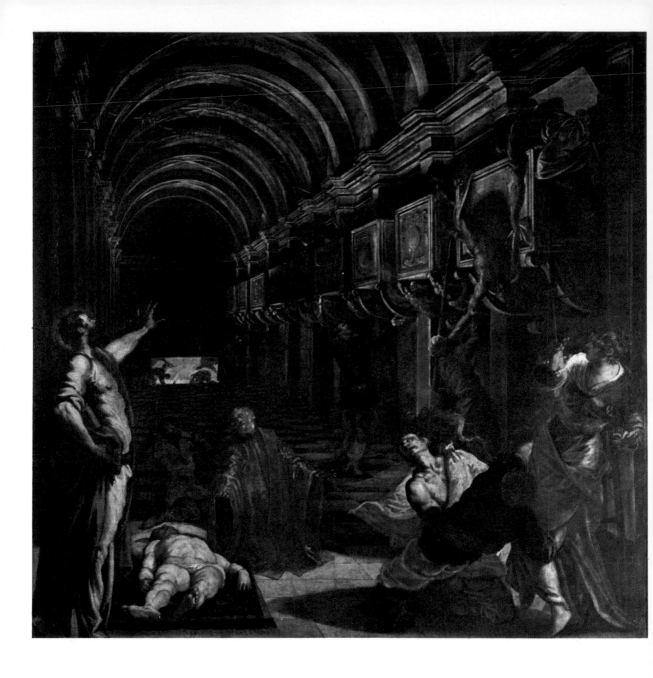

68 Tintoretto *The Finding of the Body of Saint Mark* *Circa* 1562–1566

69 Tintoretto *Removal of Saint Mark's Body* *Circa* 1562–1566→

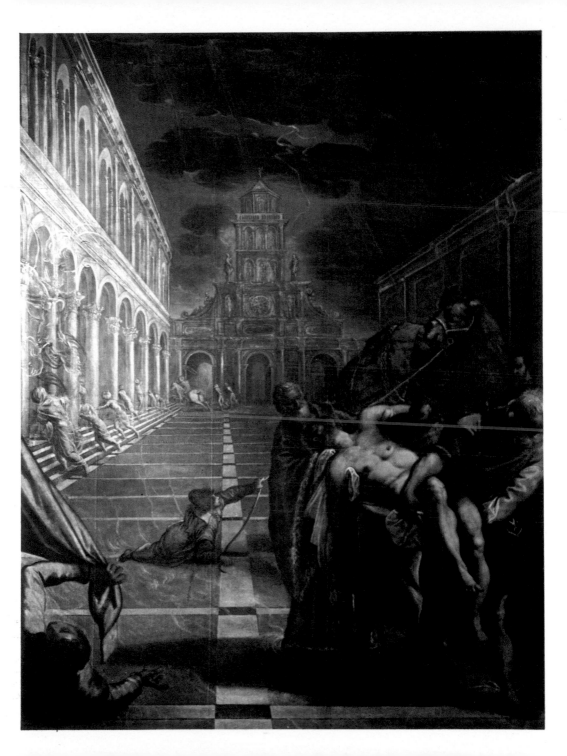

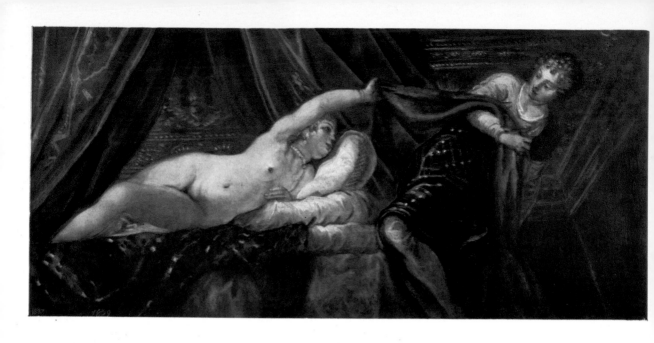

70　Tintoretto　*Joseph and Potiphar's Wife*

71　Tintoretto　*Portrait of Jacopo Soranzo*→

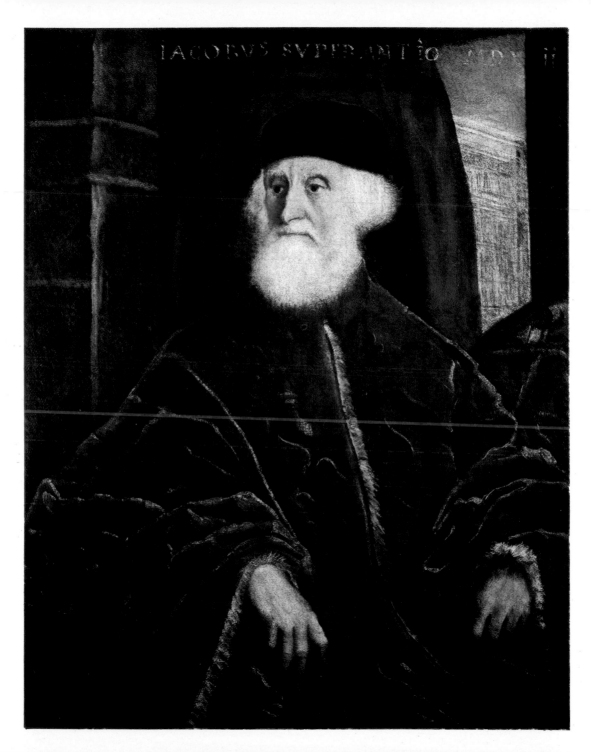

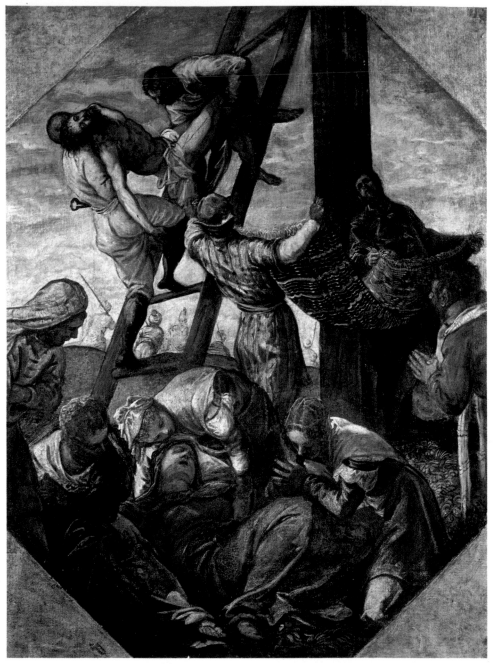

72　Tintoretto　*The Deposition*

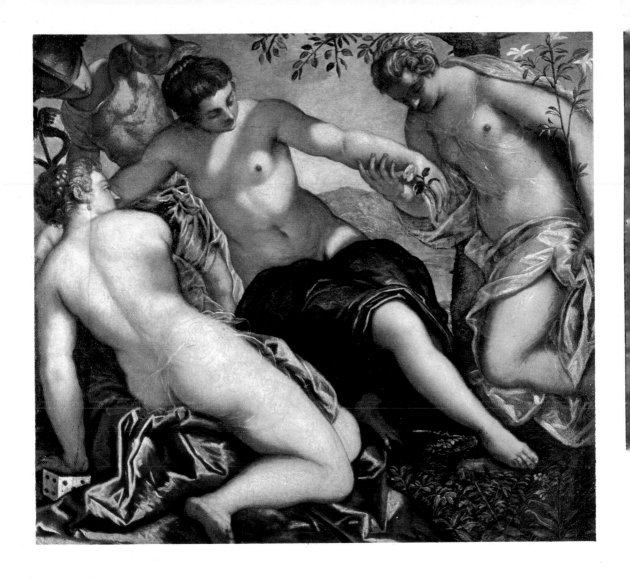

74 Tintoretto *Mercury and the Three Graces* *Circa* 1578

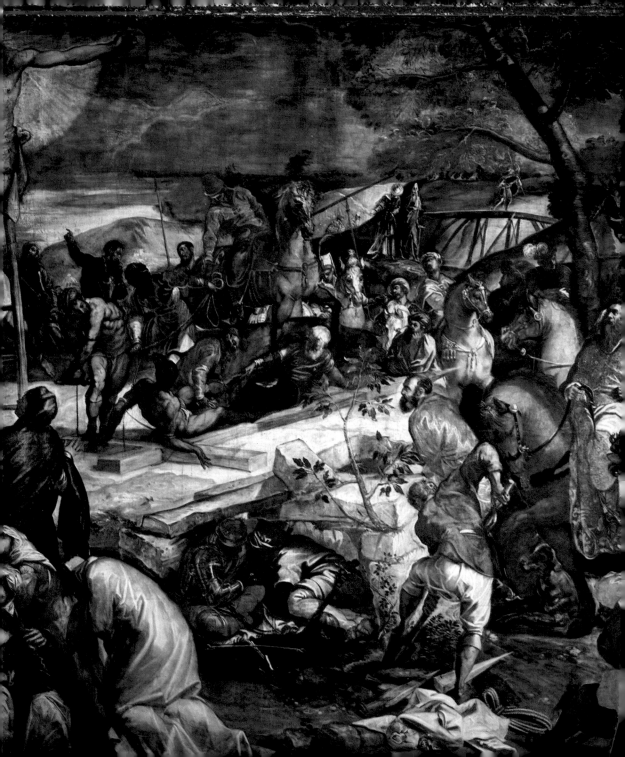

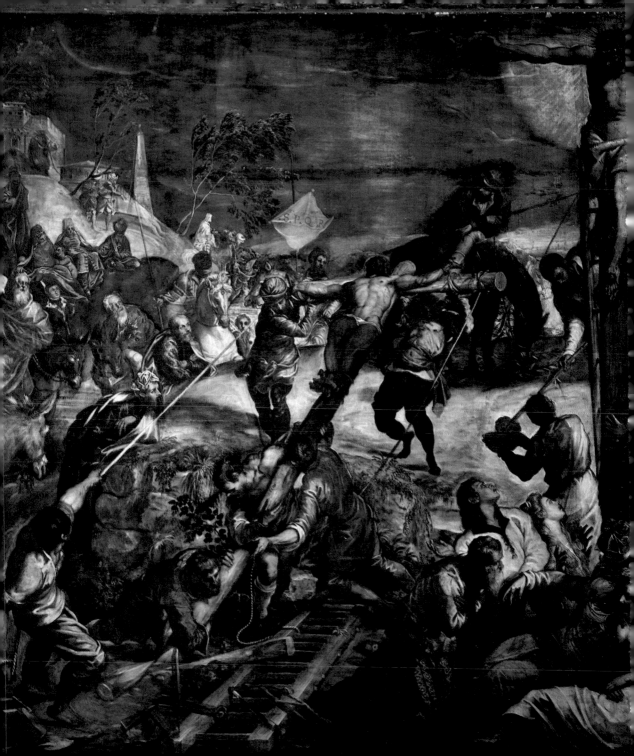

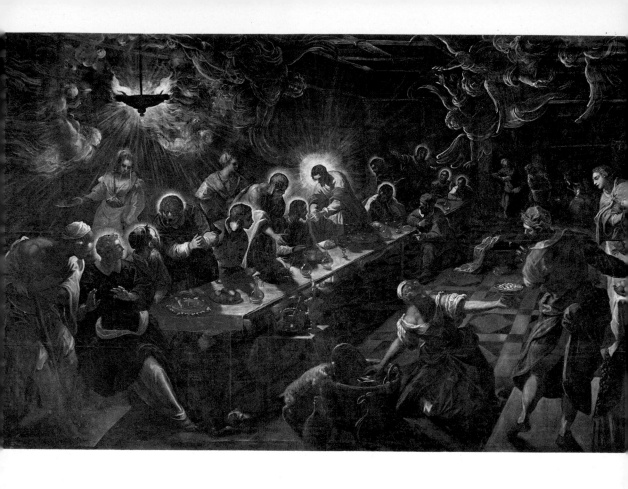

75 Tintoretto *The Last Supper* 1591–1594

Michelangelo/Titian

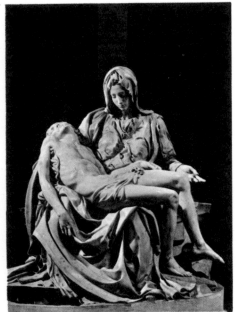

Michelangelo, *Pietà* (*Circa* 1499). One of several *Pietà*s created by Michelangelo, this shows to the full his youthful talents.

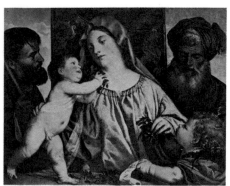

Titian, *Madonna of the Cherries* (*Circa* 1515). This work utilizes the triangular composition found in the traditional Venetian treatment of the subject.

The Italian Renaissance

To make the statement that a mere two hundred years of human history represent a period of unexcelled intellectual and spiritual growth is perhaps to exaggerate. And yet any discussion of those particular centuries, the fifteenth and sixteenth, that we know as the Italian Renaissance invites hyperbole. It is an age that does not easily lend itself to calm, systematic examination. The Renaissance presents to the world tangible evidence, in glorious painting, sculpture, and architecture, of an abstract phenomenon: a revolution of human consciousness. Realization of that phenomenon will enhance an understanding of its art and the parts played by four of its masters—Michelangelo, Giorgione, Titian, and Tintoretto.

The city-states of Italy, and particularly Florence, were the cradle of the spiritual "rebirth" and growth to which Giorgio Vasari, sixteenth-century painter and writer, gave the name "Renaissance." The Florentine republic pulsed with great commerce in the thirteenth and early fourteenth centuries. Its government was run essentially by coalitions of merchant guilds, an arrangement that eventually succumbed to instability rooted in jealous conflicts and commercial setbacks. Several attempts were made to correct

the eruptive situation; finally, one man, Cosimo de' Medici, was appointed ruler. He was the first of the famous Medici family to "rule" the republic in the unique capacity of citizen-prince. Thus fifteenth-century Florence became virtually a principality, although republican ideals were not relinquished.

Most of the princes who succeeded Cosimo were benevolent, well educated, and lovers of the arts. Even the few tyrannical rulers sustained the intense civic enthusiasm for art intrinsic to the Florentine nature by fostering creative talents. Artists were in constant demand. The services they would ultimately supply to the nobility, the Church, and the wealthy merchants were learned in the apprentice system. All artists began as students in the shops of the masters, where they learned such skills as grinding of colors, preparation of panels for painting, and gold-leaf technique. It was an effective system, but it did not survive the emergence of individualism in the Renaissance; by the late sixteenth century, art academies had virtually replaced the *bottegas* as sources of instruction.

Florence was the most politically and culturally vivacious of the Italian city-states, but it was by no means the only flourishing urban center. The Renaissance world view also characterized the other, somewhat less sophisticated thirteen states and kingdoms. Duchies, such as Savoy, Ferrara, and Milan, the republics of Siena and Venice, the Papal States—all were fiercely competitive and loyal to their own neighborhoods. Nevertheless, they shared basic cul-

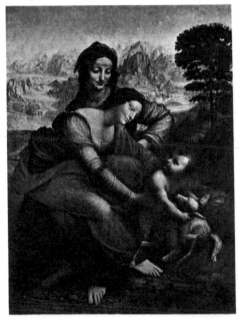

Da Vinci, *Virgin and Child* (*Circa* 1516)

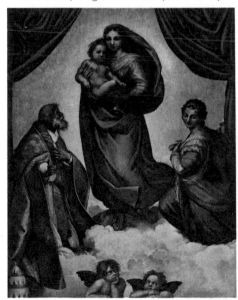

Raphael, *Sistine Madonna* (*Circa* 1513)

tural traits and were, above all, aware of their common origins in the Roman Empire.

One of the most significant facts of the Italian Renaissance was its spiritual kinship with the ideas of Roman antiquity. It is true that in Medieval times there were revivals of interest in antiquity, but they were not strongly motivated by a need for new means of understanding human existence in terms of individual human experience. Renaissance man, on the other hand, was nothing if not profoundly aware of himself as an individual. He lived in a time that represented tremendous human achievement. Contact with foreign cultures was a natural accompaniment to economic expansion. Curiosity about himself was continuously refreshed and revived by a current of ideas that flowed along with the currents of trade. Man was, in short, important of and by himself. He was capable of individual achievement—and capable also of taking pride in whatever contribution he made to understanding and appreciating the world in which he lived. The stress on materialism produced a new interest in the possibilities of happiness on earth; mortal life became at least as important a consideration as immortal life. It is not difficult to understand, then, that this growth of humanistic values found nourishment in the art and writings of Hellenic and Roman antiquity, reflecting an earlier perception and celebration of the order of nature. In imitating natural forms, Renaissance man believed he could achieve a rationally built order of reality.

. . .

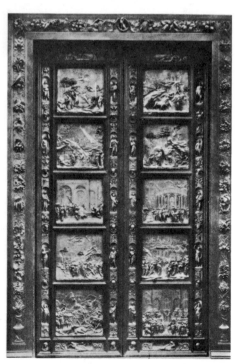

Ghiberti, *Gates of Paradise*. Lorenzo Ghiberti (*Circa* 1378–1455) labored 23 years to produce these bronze doors for the Baptistery in Florence. Michelangelo named them *Gates of Paradise*.

84

In light of the fact that humanistic thought enjoyed rather wide acceptance in Renaissance Italy—thanks in great part to the dissemination of ideas made possible by the development of book printing—it is perhaps surprising that the Roman Catholic Church did not find itself seriously challenged. (The history of the Northern Renaissance, by contrast, was explosive.) Humanists did not see themselves as pagans; compromising one's faith was not a necessary precondition for glorifying man, who was, after all, a creation of God. In any case, the Church became one of the chief reasons why the artistic applications of humanistic values flourished. The Medici family fostered art not only in their capacity as princes of Florence but as princes of the Church. True to the tradition of Lorenzo de' Medici ("the Magnificent"), whose reign in Florence from 1480 to 1492 was characterized chiefly by a policy of patronage of the arts, the Medici popes were responsible for some of the grandest artistic achievements of the age. It was not at all unusual for a Florentine prince, or indeed any ranking member of Renaissance society, to find himself suddenly elected Pope. Alexander VI, a member of the renowned Borgia family, was a papal patron of Michelangelo from 1492 until 1503. And it was for his successor, Pope Julius II, a della Rovere, that Michelangelo painted the Sistine Chapel ceiling frescoes and designed a tomb, Raphael decorated some of the Vatican apartments, and Bramante designed a new Saint Peter's basilica. The second son of Lorenzo the Magnificent, Cardinal Giovanni de' Medici, became Pope Leo X. It was Leo who commissioned Michelangelo to design the New Sacristy of San Lorenzo,

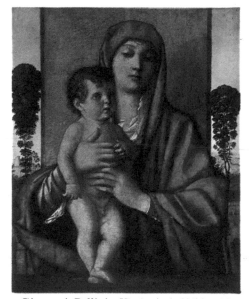

Giovanni Bellini, *Virgin and Child with Twin Trees* (1487)

the Medici church in Florence. The famous Medici Chapel was the result. It contains four of the most spiritually moving sculptural works that Michelangelo created.

Giorgio Vasari, devoted friend and biographer of Michelangelo, was born in 1511 and died in 1574. His lifetime spanned the peak of the Italian Renaissance and the mannerist period to which it gave way. Vasari's self-confidence and curiosity placed him as surely as the dates of his life in the Renaissance-man tradition; he was a painter and architect, responsible for the design of the Galleria degli Uffizi in Florence, and his *Lives of the Artists*, a work that is still a prime source of information on Italian painters, was published in two editions during his lifetime, first in 1550 and then in 1568.

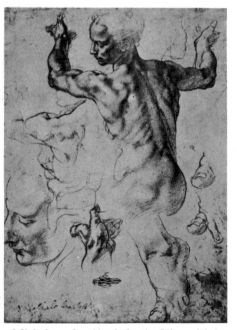

Michelangelo, *Sketch for the Libyan Sibyl.* This is one of the many drawings the artist made for the Sistine Chapel frescoes.

"When one great genius is born," Vasari says in *Lives*, "it is in the very nature of things that he shall not stand alone. In the same place, at the same time, others live, too, as though to stimulate each other by a rivalry of excellence." These remarks open his chapter on Tomaso Guidi, known as Masaccio, who was born in 1401. Though Masaccio lived only to the age of twenty-seven, he managed to develop his genius sufficiently to have earned the credit for founding Renaissance painting. His two most revolutionary achievements were the rendering of space through well-defined perspective and the use of light to model the human figure. Though he used spare, almost austere line, Masaccio created the illusion of weight and modeling. He

invested his figures with an incredible degree of realism and placed them always in a context of transcendental human emotion. Of all his works, the frescoes in the Brancacci chapel of Santa Maria del Carmine in Florence place him first among the Early Renaissance geniuses, both as artist and as teacher. Generations of painters came to the Brancacci chapel to marvel and to study the master's technique. Giotto di Bordone (1266–1337), often called the true founder of Florentine painting, was for Masaccio teacher and principal source of inspiration; Masaccio, in turn, became a major influence in the work of Leonardo da Vinci, Raphael, Botticelli, Ghirlandaio, and many others. But perhaps no artist learned more from his visits to the unofficial academy than Michelangelo.

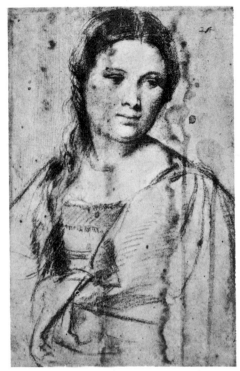

Titian, *Portrait of a Young Girl*

Michelangelo Buonarroti, titan of the Renaissance, was born in 1475, forty-seven years after the death of Masaccio. Florence by that time had become well established as "the school of the world" for artists. Young painters and sculptors from all parts of Italy came to Florence to learn and eventually to seek work, for patronage of the arts was unexceeded.

One of the great masters with whom a young apprentice might study was the fresco painter Ghirlandaio, and it was in his *bottega* that Michelangelo, not yet fourteen, began to study. Ghirlandaio excelled at drawing; his exact, hard line successfully captured two of the most important features of Florentine art at that time: movement and emo-

tion. Michelangelo was a more than apt pupil. Always ready to accept a challenge from any quarter, he soon succeeded in amazing his master with his skillful drawings, which even then hinted at his particular innovative genius.

In 1489 Lorenzo the Magnificent, citizen-ruler of Florence, decided to establish a school for sculptors, prompted by his concern over the fact that the sculptors at that time did not match in number and talent the many able painters. Ghirlandaio recommended that the fourteen-year-old Michelangelo be admitted as a student.

The school for sculptors was established in the Medici gardens, a veritable park in which was assembled the sculpture collection of three Medici generations. Included were funerary urns, sarcophagi, portrait busts, columns, medallions, and various other remnants of Roman antiquity. The sculpture-park was not the only example of the characteristic quattrocento interest in antiquity; the Medici collection also included a great many ancient texts.

Lorenzo applied the same loving encouragement to his young protégé as he did to the continuous search for antiquities and to his patronage of the contemporary arts. Michelangelo lived as a foster son in the Medici household, studying and working among the most talented and learned people of the day. Poets, Latinists, and philosophers were an everyday part of the Medici circle, and the boy did not fail to be stimulated by such a heady intellectual atmosphere.

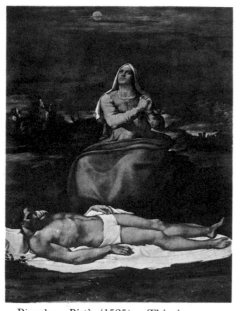

Piombo, *Pietà* (1525). This is a representative masterpiece of Sebastiano del Piombo (1485–1547), a Venetian painter of religious subjects.

By the time of Lorenzo's death, in 1492, Michelangelo had begun his lifelong, loving attack on marble in two works of great promise: *Madonna of the Stairs*, a low-relief carving reminiscent of Donatello, and *The Battle of the Centaurs*, a complicated and vigorous composition that shows an expressive handling of the nude figure.

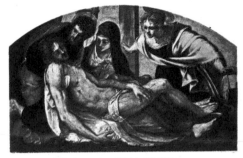

Tintoretto, *Pietà* (1565)

Within two years after Lorenzo's death, the political atmosphere of Florence became charged with the currents of guild jealousies and political intrigues. Adding to the turmoil was the impact of Girolamo Savonarola, prior of the Dominican house in Florence, San Marco. This angel of destruction launched a fierce yet eloquent attack on the moral laxity of the Florentines and on the general moral corruption of the Church itself. By 1494, the year the Medici government collapsed, he had become powerful enough to consolidate the city as its spiritual ruler. At the same time, Italy was being invaded by Charles VIII of France; in an effort to gain strength and simultaneously defy Pope Alexander VI, Savonarola allied himself with Charles. It was not until 1498, when the Dominican was burned at the stake, that Florence became relatively calm. Those years were an ominous sign of the sporadic but violent upheavals that would haunt the cinquecento.

Michelangelo left Florence in 1494, returned briefly the next year, and then went to Rome, in 1496, for five years. During that time he executed the *Pietà* (illustration, p. 82)

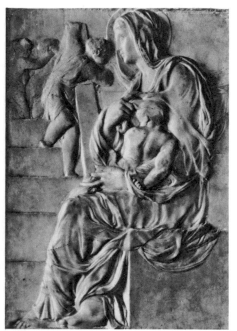

Michelangelo, *Madonna of the Stairs.* This relief carving and the one following were done when the artist was not yet twenty.

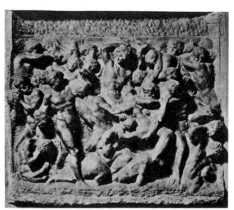

Michelangelo, *The Battle of the Centaurs*

for Saint Peter's, commissioned by the French cardinal Jean Bilheres de Lagraulas. The other extant work of his first Roman period is the *Bacchus,* which in its mythological subject matter and, to a lesser degree, in its execution shows a correspondence to the artistic conceptions of antiquity—just as the *Pietà* reflects the Florentine taste of the quattrocento. Rome, as the chief center for cultural antiquities, must have been an attraction for the young artist, affording him much opportunity for study of ancient sculpture. However, little is known of his daily activities during this sojourn. The outstanding fact is that the *Pietà* gained him immediate acclaim. By the time he returned to Florence, probably in 1501, he was famous. For the next five years, working in the city that was then lionizing another artistic genius, Leonardo da Vinci, Michelangelo developed his classic style in the heroic figures of the *David* (Plate No. 1) and the *Doni Tondo* (Plate No. 11). The latter reflects Leonardo's influence in the contrast between the pagan background and the holy foreground scene, a fashionable device of the late fifteenth and early sixteenth centuries.

During the pontificate of Julius II (1503–1513), Michelangelo began a phase characterized by monumental projects. The Pope asked the artist to design and execute his mausoleum. The project was never completed, although it was to haunt Michelangelo's creative spirit for forty years. Julius, whose temperament was as tumultuous and bold as the artist's own, changed his mind after a few months. Three years later, in 1508, he commissioned what proved to be the masterwork of Michelangelo's early maturity: the

Sistine Chapel ceiling frescoes (Plate No. 17). The paintings took four years to complete, 1508 to 1512. At exactly the same time, Raphael, who must stand beside Leonardo and Michelangelo in the top rank of Renaissance genius, executed his Vatican frescoes.

Two spiritual trends of the Renaissance period left their mark on Michelangelo's thought and art: the Platonic love of physical beauty as a vessel for the divine idea, and the movement toward Catholic reform, the seeds of which were perhaps planted by the preachings of Savonarola. The desire for spiritual liberation, an unadulterated union with the Divine, is seen as early as 1534 in the seated figures of the Medici Chapel. Contemplation of the power of creation, a power that goes beyond man to include the universe itself, is the thematic substance of the figures. The creations of Michelangelo's entire career tell of a man who strove to concentrate on the interior images of his spirit. Working within the Tuscan artistic context of rigorous line and form, he realized an ideal of plasticity. Figures could now be freely placed in space; motion and rhythm raised them out of their earthly confines. After the unveiling of Michelangelo's *Last Judgment*, in 1541, a taste for monumentally sublime art forms began to be seen in the work of European painters. Michelangelo's starting point was the Florentine Renaissance, the elements of which he mixed in new combinations as his inner demands required. Unlike Leonardo, who examined the phenomena of the visible world, Michelangelo turned instead to the tensions of the

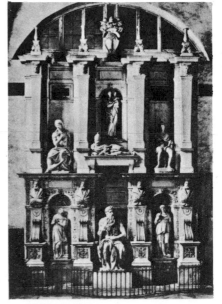

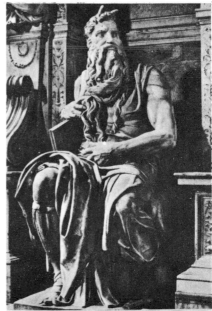

(top) Michelangelo, *Tomb of Pope Julius II* (1505–1545)
Michelangelo, *Moses* (1513–1516)

soul. For he sought to express knowledge of the human spirit.

In direct contrast to the principles of Florentine art, which stressed form and motion, the Venetian school based its style on the impact of color. The guiding principle of Venetian painting, set by Giorgione with the work of Giovanni Bellini as precedent, was direct sensuous appeal through the use of rich color. The Venetian preference for chromatic richness was no doubt in part due to the pleasure-seeking spirit of the merchant citizens of Venice, a spirit nurtured by centuries-old contact with Oriental culture. The artist whose generous legacy of extraordinary genius most clearly exemplifies the heart of Venetian painting is Tiziano Vecellio, known as Titian. Michelangelo and Titian represented the spirit of the Italian Renaissance, though in quite different ways, and both brought the intensity of their individual natures to bear on the classical style of the period. It is the differences in their personalities and in the traditions of their backgrounds that characterize the refinements they brought to that style.

Titian, who was born in the foothills of the Alps about thirteen years after Michelangelo, centered his artistic activity almost exclusively in Venice. In his youth he came under the influence of another Venetian light, whose brilliant flame burned only briefly, Giorgione. In the few years allotted to him—he died in 1510 at the age of thirty-two—Giorgione brought unique poetic powers of imagina-

(top) Michelangelo, *Conversion of Saint Paul* (1542–1550)
Michelangelo, *Crucifixion of Saint Peter* (1542–1550). These frescoes were executed for the Vatican Pauline Chapel.

92

tion to his subjects. Much of Venetian painting was done for the elite generation of merchants and aristocrats, as opposed to the Church patronage that dictated the choice of subject for the Florentines. Instead of the traditional Christian themes, Giorgione's clients sought pagan subjects. His discovery of a new natural universe became the point of departure for Titian. After the death of Giorgione, Titian became the hope of Venetian art, and he quickly turned that hope into a reality.

Titian did not specialize in any particular area. During his long career, he produced religious paintings and altarpieces, allegorical works, and numerous portraits of the great and near great. In his early period, he added realism, classical perfection, and a highly developed sense of movement to Giorgione's style; his later period shows a deepening of mood, a more internalized vision.

(left) Dome of Saint Peter's in Rome. The Campidoglio. Michelangelo designed the Campidoglio in 1546, a year before he started work on Saint Peter's. Conceived as a kind of civic center, it sits atop the Capitoline Hill in Rome.

Often using a rough canvas, Titian applied a great many color glazes to achieve the magnificent and original chromatic effects with which he conveyed the high degree of intellectual and emotional expressiveness that characterizes all of his work. His influence was carried through generations of painters of every school; his later paintings especially foreshadowed the work of the impressionists.

Jacopo Robusti, known as Tintoretto, was born in Venice in 1518. As a student in Titian's studio, he could not fail to be influenced by the master. By the time he began to paint the works of his maturity, it was the mannerist aspect of Titian's work that he most developed.

The influence of Michelangelo had penetrated the Venetian tradition by the mid-sixteenth century. Tintoretto assimilated and synthesized the most intrinsic characteristics of Michelangelo and Titian: the rigorous plastic design of the Florentine, and the rich chromatics of the Venetian. There is even a traditional story to the effect that Tintoretto kept a motto in his studio: "Michelangelo's drawing and Titian's colors." But the special mark of Tintoretto's genius is the sense of drama and motion with which he dynamized his subjects. Working with furious speed and usually on a huge canvas, he gave traditional themes daring new perspective and lighted his figures according to the dictates of his appetite for high drama.

The power of Tintoretto's canvases owes much to a Venetian discovery of the time: the added means of ex-

Giorgione, *Fresco* (1508). Thought to be a joint venture of Giorgione and Titian, this work is made up of medallions, cameos, and Latin mottoes.

pression resulting from obviously applied paint. For some this new exploitation of method was visible brushwork; for Titian it was the layering of color upon color. Tintoretto used well-diluted paints so that they easily ran over his large canvases, allowing him to work at a speed almost comparable to that with which his ideas flashed into his mind.

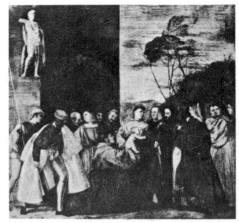

Titian, *Saint Anthony Healing a Newborn Child* (1511)

The development of such technical refinements paralleled the changing tastes in the mid-sixteenth century. Patrons were demanding more emotion in their paintings. In seeking expressive effectiveness, the artists began to paint more affectedly, and in so doing contributed to the so-called mannerist movement, which for approximately thirty years dominated the artistic interval between the classically oriented dynamism of the High Renaissance and the mobile spatial geometry of the seventeenth-century baroque (see notes, Plate No. 18). In revolt against the equilibrium of form and proportions, the mannerists placed elongated figures in contorted postures and deliberately confused spatial relationships. But even as they counteracted the stylistic rules of the Renaissance, they extended still further the liberated spirit of that period.

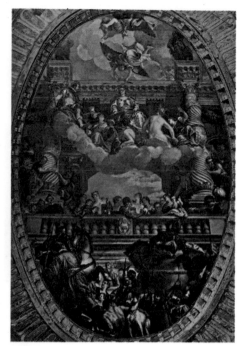

Paolo Veronese, *The Triumph of Venice* (1584)

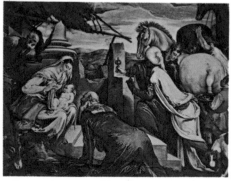

Jacopo Bassano, *The Adoration of the Magi*

NOTES ON COLOR PLATES

Michelangelo Buonarroti (1475–1564)

1. *David*

 1501–1504 Marble 514.4 cm Galleria dell' Accademia, Florence

 Michelangelo had gained fame and recognition with his *Pietà*, which he completed in 1499 for Saint Peter's in Rome. When he returned to Florence, he received the commission for this work jointly from the cathedral there and the Guild of Wool Merchants. The figure of David, guarded, strong, and ready for action, sums up the ideal Renaissance man and is the greatest masterpiece of the artist's early period. As such it established Michelangelo's reputation as a mature artist. The *David* stood in front of the Palazzo Vecchio until 1873, when it was removed to the greater protection of the Accademia. In 1910 a copy was placed in the original spot.

2. Overleaf: *Tomb of Giuliano de' Medici*

 1520–1534 Marble Medici Chapel, Church of San Lorenzo, Florence

3. *Night*

4. *Day*

5. Overleaf: *Tomb of Lorenzo de' Medici*

 1520–1534 Marble Medici Chapel, Church of San Lorenzo, Florence

6. *Dusk*

96

7. *Dawn*

Pope Leo X and Cardinal Giulio de' Medici, Michelangelo's patrons, intended that he design tombs for Lorenzo the Magnificent and his brother Giuliano, and for Duke Giuliano and Duke Lorenzo, younger members of the family. But Michelangelo finished only the ducal tombs before he left Florence in 1534, never to return. The chapel itself, also left unfinished, is a perfect structural compliment for the tombs, preserving the sense of calm acceptance of death that they convey. The ducal figures are not so much feature-for-feature representations as striking monuments to the soul of man in the midst of transferring its worldly host to the eternal realm of the spirit. The allegorical figures of *Night, Day, Dusk*, and *Dawn* are all of a rather uneasy attitude, disquieted by death. Their sorrow is in direct contrast to the noble calm of the dukes.

8. *Saint Matthew*

> *Circa* 1501–1506 Marble Height: 271 cm Galleria dell' Accademia, Florence

Apparently this unfinished work was to be one of twelve apostle figures Michelangelo was commissioned to do for the cathedral in Florence. Especially interesting is the fact that it shows a stage in the sculptor's creative process.

9. *Dying Captive*

> 1513–1516 Marble Height: 230 cm Louvre, Paris

During a three-year period immediately following the death of Pope Julius II, Michelangelo worked on Julius's tomb, the plan for which had by now been modified from a four-sided freestanding construction to a wall monument. In that time he executed three figures for the tomb: *Moses*, thought by some to be his greatest single sculpture, *Dying Captive*, and *Heroic Captive*, both of which are portrayals of man's anguished struggle against the shackling of the human spirit. (For reproductions of *Moses* and the *Heroic Captive*, see List of Illustrations.)

97

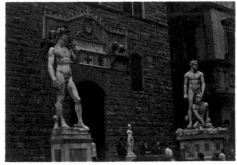

Copy of Michelangelo's *David* in the Palazzo Vecchio, Florence

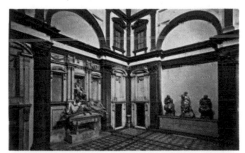

Interior of the Medici Chapel, Florence (bottom) Michelangelo, *Madonna and Child* in Medici Chapel (1524–1534)

10. *Rondanini Pietà*

1555–1564 Marble Height: 190.5 cm Castello Sforzesco, Milan

Michelangelo worked on these sorrowful figures just a few days before he died. They perhaps reflect his desire to seek union with God. Mary appears to be leaning against Jesus, as much seeking support in her sorrow as lending it. Both figures derive unforgettable emotional power from the rough-surfaced, unfinished quality of this work—as if through a fusion of the last resources of strength they had emerged from the unyielding stone. The legs and the free right arm are vestiges of an earlier version.

11. *Doni Tondo*

1504 Wood, resin and tempera Galleria degli Uffizi, Florence

This tondo, painted for the wedding of Agnolo Doni and Maddalena Strozzi, is the earliest known painting by Michelangelo and also the only absolutely authentic one, apart from the frescoes. The unity of the Holy Family is achieved with the spiraling effect typical of Michelangelo's vision of forms. Rich in controlled motion and chiaroscuro relief, the group has all the earmarks of the sculptor's animated conception of the human figure.

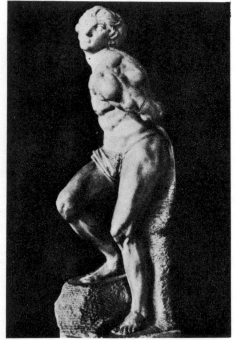

Michelangelo, *Heroic Captive* (1513–1516)

12. Interior of the Sistine Chapel

1473 (building completed) The Vatican, Rome

This long, tunnel-vaulted room is the Pope's private chapel, and is also where papal elections are held. Built for Pope Sixtus IV, it boasts large frescoes by Pinturicchio, Botticelli, Signorelli, Ghirlandaio, Rosselli, and Perugino. Between 1508 and 1512, Michelangelo painted the ceiling in nine main scenes, from the Creation to Noah, and surrounded them with Prophets, Sybils, and nude youths. (See Plate Nos. 13, 14, 15, 16, 17.) Thus the simple, almost austere architecture of the chapel took on the very image of the High Renaissance.

98

13. *Libyan Sibyl*

14. *Deluge*

15. *The Creation of Adam*

16. *Zechariah*

17. Frescoes of the Sistine Chapel ceiling
 1508–1512

18. Overleaf: *The Last Judgment*
 1536–1541 East wall of Sistine Chapel

In 1535 Michelangelo began the cartoons, and the following year the painting. The upper, Paradise section took four years, the lower section only one. After removing the mortar and resin ground for oil painting, which had been applied by Sebastiano del Piombo, he painted in fresco on a ground of damp lime and mortar. Except for the aid of a color grinder, Michelangelo did the entire painting by himself, an area measuring 48 ft. by 44 ft. (See following two plates.)

19. *Christ as Judge*

20. *The Damned*

Giorgione (*Giorgio da Castelfranco*) (Circa *1478–1510*)

21. *Castelfranco Madonna*
 1505 Oil on wood 200 × 152 cm Church of San Liberale, Castelfranco Veneto

The Madonna is attended by Saint George, left, and a thoughtful Saint Francis in a simply executed work that reveals the artist's debt to his master, Giovanni Bellini. It is the only extant Giorgione altarpiece.

99

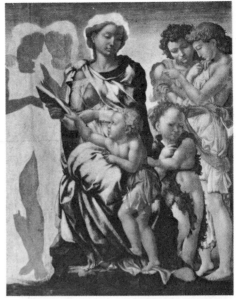

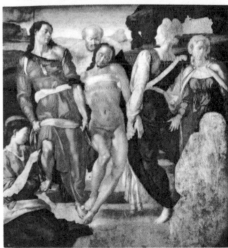

(above) Michelangelo, *Madonna and Child with Saint John*
Michelangelo, *Entombment*

The Division of Light from Darkness

The Creation of Sun and Moon

The Division of Waters and Land

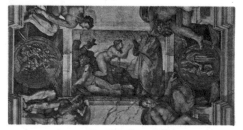

The Creation of Eve

The Fall

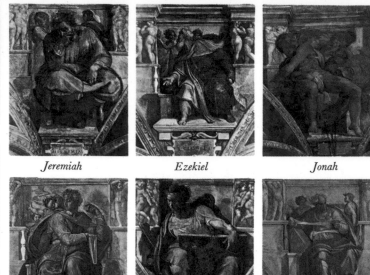

Jeremiah *Ezekiel* *Jonah*

Isaiah *Daniel* *Joel*

22. *The Tempest*

> *Circa* 1505–1508 Oil on canvas 78 × 72 cm Galleria dell' Accademia, Venice

A nursing mother, a passing stranger's glance—or is it the fond look of a protective lover? Narrative particulars were not Giorgione's chief concern. More important was the mood itself, however enigmatic, couched in and magnified by beautiful landscape and romantic, fantasy figures.

23. *The Infant Moses before Pharaoh for the Trial of Gold and Fire*

> Oil on wood 90.0 × 71.8 cm Galleria degli Uffizi, Florence

It is not certain that attribution of this painting to Giorgione is justifiable. First thought to be the work of Giovanni Bellini, it has since been described as a design by Giorgione that was executed by an artist of his school, Giulio Campagnola. In any case, it must truly belong to the early cinquecento period of lyrical, poetic compositions vitalized by dramatic events.

100

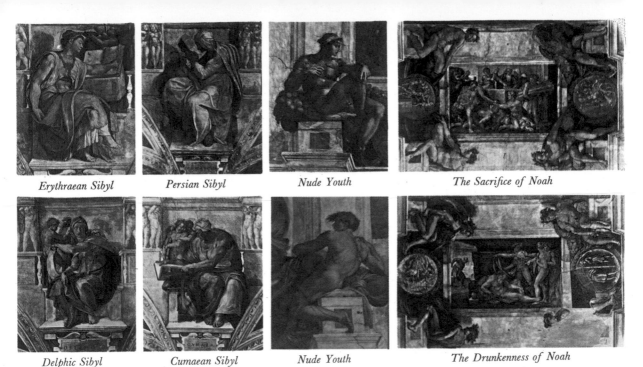

Erythraean Sibyl Persian Sibyl Nude Youth The Sacrifice of Noah

Delphic Sibyl Cumaean Sibyl Nude Youth The Drunkenness of Noah

24. *Portrait of a Young Man*

Oil on canvas 58 × 46 cm Kaiser Frederick Museum, Berlin

Few scholars question the authenticity of this work. The anonymous young man has the typical, slightly melancholic expression found in Giorgione faces, and in spite of surface damage, the painting shows the artist's rich sense of color.

25. *Laura*

Oil on canvas 41.0 × 33.6 cm Kunsthistorisches Museum, Vienna

Although doubts still persist as to the authenticity of this portrait, it received respectably solid recognition as a Giorgione in the late nineteenth century. Whether the work is meant to be a portrait of an actual woman or, as some scholars think, a laurel tree personified is not known.

101

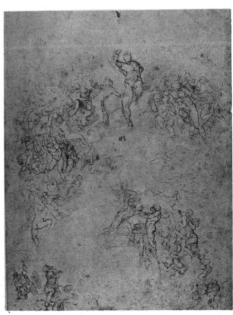

Cartoon for *The Last Judgment*

26. *The Old Woman*

Oil on canvas 69 × 60 cm Galleria dell' Accademia, Venice

Still another unauthenticated work is this realistic rendering of an unidentified woman. It does bear out at least two Giorgione characteristics: the choice of nonspecific subjects—as opposed to the formal portraits and recognizable historical or mythical figures that were favored by other artists of the time—and the delicate evocation of mood.

27. *The Three Philosophers*

Circa 1506–1508 Oil on canvas 123.5 × 144.5 cm Kunsthistorisches Museum, Vienna

As can be seen in *The Tempest* as well as in this painting, Giorgione's particular forte was a compelling unity of natural background with subject. The illusion of depth is preserved, yet the distant scenes are as well lighted and purely colored as the foreground figures and setting. The artist left this work unfinished; it was completed by Sebastiano del Piombo.

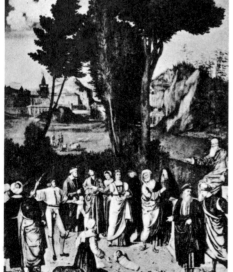

Giorgione, *The Judgment of Solomon*

28. *Sleeping Venus*

Oil on canvas 108.5 × 175.0 cm Gemäldegalerie, Dresden

This painting and three others—*The Tempest, The Three Philosophers, Christ Bearing the Cross* (not shown in this book)—are the only four that can be certainly attributed to Giorgione. The artist's poetic conception of the love goddess is an interesting contrast to the alluring temptress by Titian (No. 46), who, incidentally, filled in the landscape portions left unfinished by Giorgione.

29. *Fête Champêtre*

Circa 1505–1510 Oil on canvas 110 × 138 cm Louvre, Paris

Opinion is divided as to whether this picture was painted by Giorgione or Titian—indeed, solid arguments can be made for

either. Giorgione's soft delineation of figures and his love for lyrical mood are certainly evident here; yet the somewhat dark richness of color and the rather strongly drawn male faces bespeak Titian's hand. Perhaps the most logical conclusion would be that the painting was planned and begun by Giorgione and finished by Titian. In any case, it has survived as one of the greatest masterpieces of the early sixteenth-century Venetian school—in particular providing a wealth of inspiration for the nineteenth-century impressionists.

30. *The Concert*

Circa 1515 Oil on canvas 108 × 122 cm Palazzo Pitti, Florence

This work also presents the problem of unsolved authorship. It was perhaps begun by Giorgione some years before his death and left unfinished in his studio along with several others. Titian, who was a pupil of Giorgione's, most likely worked on those canvases, adding to them in greater or lesser degree as they required. Certainly *The Concert* shows noticeable differences in style: the Titianesque figure is strongly drawn, dramatic, definite in feeling, providing high contrast with the enigmatic, softly defined side figures that are surely Giorgione's.

Titian (Tiziano Vecellio) (1488–90 to 1576)

31. *Sacred and Profane Love*

Circa 1515 Oil on canvas 118 × 279 cm Galleria Borghese, Rome

Titian painted this work a few years after the death of his master, Giorgione. The explicitness of the allegory, which upstages the landscape setting, the strong, bold brushwork, and the rich variation in textures are part of Titian's artistic signature and represent some of the chief differences between his work and that of his teacher.

103

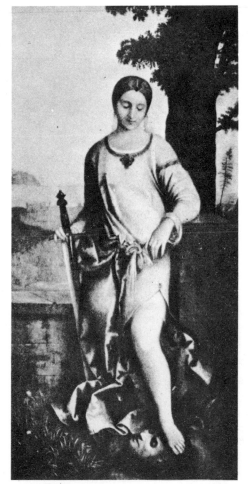

Giorgione, *Judith*. The Apocrypha tells of a Jewess, Judith, who killed an Assyrian general, Holofernes, in order to save her people from destruction.

32. *Flora*

Circa 1515 Oil on canvas 79 × 63 cm Galleria degli Uffizi, Florence

Richness of color and perfection of face and form characterize this aptly titled portrait of ideal beauty. It is one of several paintings of Venetian women that Titian did in his early period, and shows a conception of womanly beauty that was to remain typical of him throughout his career.

33. *Vanity*

Oil on canvas 97.3 × 81.0 cm Alte Pinakothek, Munich

It was not until late in the nineteenth century that a scholar named Morelli attributed this painting to Titian. It is now generally considered as belonging to the same period as *Flora*.

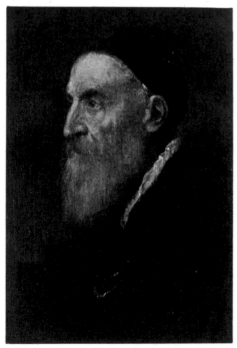

Titian, detail of *Self-Portrait* (*Circa* 1565). Vasari saw this profile painting of Titian as an old man on a visit to the master.

34. *Assumption of the Virgin*

1518 Oil on wood 690 × 360 cm Church of Santa Maria dei Frari, Venice

Gracing the main altar of the church where Titian is buried, this monumental work effectively balances the vast Gothic space in which it is set. Titian's conception of the holy event, with its vigorous figures richly colored and sensuous, caused some doubt among his patrons. On the day of its unveiling, however, the painting evoked unanimous positive response; the representative of the Holy Roman Emperor even offered to buy it then and there.

35. *Bacchanal of the Andrians*

1518–1519 Oil on canvas 175 × 193 cm Museo del Prado, Madrid

Alfonso d'Este, Duke of Ferrara, was typical of Renaissance noblemen in his taste for ancient Greek and Roman art; when he decided to decorate the walls of his famous alabaster chambers, he commissioned Titian to execute three paintings on the

theme of the joys of love and wine. They were to be done in imitation of ancient paintings described in classical literature. *Bacchanal of the Andrians* was such a copy, a painting of a festival honoring Bacchus on the island of Andros as described in *Imagines* by Philostratus the Elder. The other two works Titian "reproduced" were the *Worship of Venus* and *Bacchus and Ariadne*. One of the delights of living on Andros was, according to Philostratus, access to a spring from which wine flowed. The theme is a sensualist's delight, and Titian did it justice. But what lends particular charm to this painting is the absence of lasciviousness. The revelers seem to be enjoying themselves within the bounds of a code of behavior that demands grace, beauty, and restraint even in the midst of abandon.

36. *The Birth of Venus*

> *Circa* 1517 Oil on canvas 73.6 × 58.4 cm National Gallery of Scotland, Edinburgh

Venus, wringing out her hair after just emerging from the sea, is a refreshing study in depth of the flesh-and-blood vigor with which Titian managed to inform his female figures. For him vitality was intrinsic to beauty and the *sine qua non* for conveying dramatic meaning.

37. *Portrait of a Man*

> *Circa* 1520 Oil on canvas 89 × 74 cm Alte Pinakothek, Munich

The name of the model is unknown, although at one time it was thought to be Pietro Aretino, poet, playwright, and friend of Titian's. Though supposedly from Titian's early period, the portrait carries the thoughtful, luminous quality of the artist's mature work.

38. *Madonna with the Rabbit*

> 1530 Oil on canvas 71 × 85 cm Louvre, Paris

Federigo Gonzaga, Duke of Mantua, had a penchant for religious paintings. The more tearfully evocative they were the

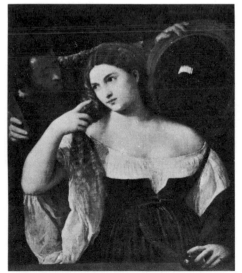

Titian, *Young Woman at Her Toilet* (1511). The model for this early work was the mistress of Alfonso I of Ferrara.

better he liked them. In this moving scene, Mary's love for her child gives her an expression not of joy, but profound sadness. Her eyes seem to see beyond her child's innocent happiness to the devastating loss that lies in the future.

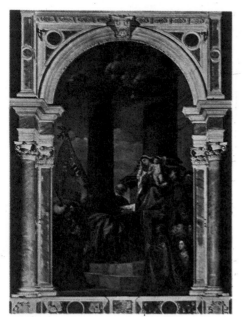

Titian, *The Pesaro Madonna* (1519–1526). Along with the *Assumption of the Virgin*, this painting is owned by the Church of Santa Maria dei Frari in Venice.

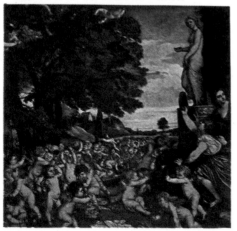

Titian, *Worship of Venus* (1518–1519). The goddess of love and fertility presides over this cupids' frolic, done in the same period as *Bacchanal of the Andrians*.

39. *Allegory*

Oil on canvas 121 × 107 cm Louvre, Paris

Very little is ascertainable about this painting; both the date and the exact allegorical meaning lie shrouded in mystery. One theory holds that the artist presented this work as a gift to his wife, who died in 1523.

40. *Saint Mary Magdalen*

Circa 1533 ·Oil on wood 84 × 69 cm Palazzo Pitti, Florence

There are several theories about the exact origins of this painting; some scholars think it is a version of a work commissioned by Francesco Maria I, Duke of Urbino. Others feel that it may not be Mary Magdalen at all, but rather an inspired rendering of a classical Venus. Whatever the true theme of this work, the remarkable chromatic treatment of the hair, the perfectly modeled figure, the exquisite proportions of the face are all unmistakably the hand of Titian.

41. *Portrait of the Emperor Charles V with His Dog*

1532–1533 Oil on canvas 192 × 111 cm Museo del Prado, Madrid

Titian's inspiration for this work was a portrait by Jakob Seisenegger, an Austrian painter. So much did it please Charles that he decided no one but Titian would paint him from then on. Naturally the artist's already solid reputation as a portraitist was raised to new heights, and he was more sought after than ever by prominent figures.

42. *Portrait of Francis I*

1538? Oil on canvas 109 × 89 cm Louvre, Paris

Titian did take his inspiration from another painter for the Emperor's portrait, but he had also seen and presumably sketched him. This was not the case with Francis I, for Titian never actually met him. This portrait was done after a medallion designed by Benvenuto Cellini, Florentine goldsmith and sculptor of the sixteenth century. That fact probably accounts for the profile view, unusual in Titian's works.

43. *La Bella*

Circa 1536 Oil on canvas 89 × 75 cm Palazzo Pitti, Florence

Color creates the atmosphere in this work, a fine example of Titian's best portrait period. It is an interpretation of a personality whose very essence is grace and harmony. To the Renaissance man such grace was the particular quality of woman and the principal—and logical—source of her beauty. Though the identity of the subject remains a mystery, the portrait was commissioned by Duke Francesco Maria I della Rovere. An interesting footnote to the history of this painting is that Titian was asked to paint an allegorical cover, or timpano, for it, a practice designed to protect those paintings considered particularly valuable.

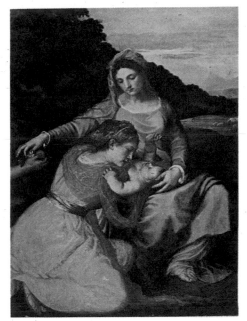

Titian, detail of *Madonna and Child with Saint John and Saint Catherine*

44. *Jupiter and Antiope* (detail)

Oil on canvas 196 × 385 cm Louvre, Paris

An intimate, poetic union of figures with nature is achieved in this lyrical painting. The soft rendering of the subjects and the sense of landscape rediscovered is reminiscent of Giorgione. (The picture is sometimes referred to as the "Venus du Pardo.")

45. *Presentation of the Virgin in the Temple* (detail)

1534–1538 Oil on canvas 345 × 775 cm Galleria dell' Accademia, Venice

This huge canvas covers one whole refectory wall in a building that was once the monastery of Santa Maria della

107

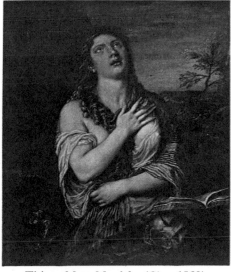

Titian, *Mary Magdalen* (*Circa* 1560)

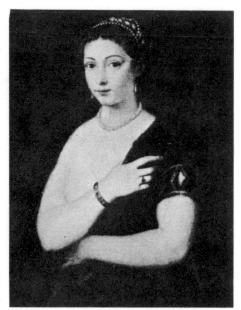

Titian, detail of *Woman with a Fur*

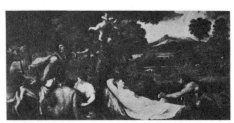

Titian, *Jupiter and Antiope*

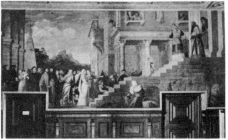

Titian, *Presentation of the Virgin in the Temple*

Carità, and is now the Galleria dell' Accademia. The story of the Virgin's presentation, taken from an apocryphal book of the Bible, was a favorite religious theme of Renaissance artists.

46. *Venus of Urbino*

Circa 1538 Oil on canvas 119.5 × 165.0 cm Galleria degli Uffizi, Florence

This painting derives its name from the fact that it was one of a collection of masterpieces belonging to the last Duke of Urbino. Despite the realistic setting and individualized figure, it is the Titian Venus that is closest to Giorgione's *Sleeping Venus* (No. 28). The model appears also in *La Bella* (No. 43).

47. *Pope Paul III*

Oil on canvas 114 × 89 cm Museo di Capodimonte, Naples

In this penetrating study of senility, only the eyes remain as evidence of the wily strength of the Farnese Pope, successor to Clement VII and member of the family that convinced Titian to come to Rome. The portrait is one of two commissioned by Paul in 1543.

48. *Saint John the Baptist*

Circa 1540 Oil on canvas 210 × 134 cm Galleria dell' Accademia, Venice

There is some evidence of slightly affected stylization, or mannerism, in this bold, powerful image. Mannerism, in architecture and sculpture as well as painting, characterized the bridge period between the High Renaissance and the emergence of the baroque style. It was a deliberate turning away from classical rules, aiming at tension instead of harmony, strain rather than repose. A mannerist painting is often most noticeable in its lack of spontaneity, as can be seen here. This work was painted for the Church of Santa Maria Maggiore in Venice.

108

49. *Ecce Homo*

1543 Oil on canvas 240 × 360 cm Kunsthistorisches Museum, Venice

Titian's highest achievement of the early 1540s, this work was painted for Giovanni d'Anna, a Flemish merchant. Henry III of France offered 800 ducats for it. In unifying many diverse figures, each virtually a pictorial entity, the artist created a stunning example of his genius for harmonizing separate elements without expending their vitality.

50. *Portrait of a Man*

Oil on canvas 90 × 73 cm Fesshu Museum, Ajaccio

There is some doubt as to whether this portrait of an unknown man is an original Titian.

51. *Portrait of Charles V at the Battle of Muhlberg*

1548 Oil on canvas 332 × 279 cm Museo del Prado, Madrid

Titian was a guest at the Imperial court when Emperor Charles V returned from his victory over John Frederick, a powerful Protestant rebel who had challenged the Vatican-controlled Hapsburg Holy Roman Empire. Not only did Titian memorialize Charles's triumph; he also painted a portrait of the captive John Frederick, whom Charles had brought with him.

52. *Portrait of Isabella of Portugal*

Circa 1548 Oil on canvas 117 × 93 cm Museo del Prado, Madrid

Charles V was said to have kept this portrait of his wife close to him throughout his life. Though it was painted after Isabella died, the artist managed to inform his subject's beauty with the spark of vitality.

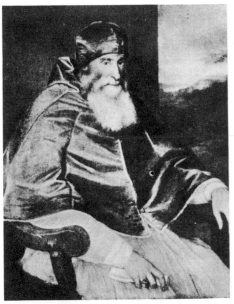

Titian, *Portrait of Pope Paul III in a Hat*

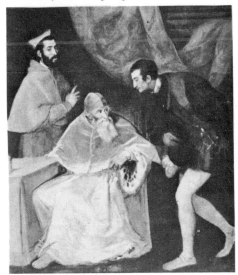

Titian, *Pope Paul III and His Grandsons*

109

53. *Portrait of Jacopo Strada*

1567–1568 Oil on canvas 125 × 95 cm Kunsthistorisches Museum, Vienna

In this interesting portrait the focus is not exclusively on the central figure. Titian's interest expanded to include the play of light on objects of various textures. The subject has been caught in a moment of action rather than frozen in the immobile, reflective stance of ordinary portraiture.

54. *Portrait of the Doge Francesco Venier*

Oil on canvas 113 × 99 cm Thyssen Collection, Lugano

Francesco Venier was the Doge of Venice from 1554 to 1556 and, no different from other notables of the day, wished to be memorialized in that capacity by the period's most famous portraitist.

55. *Danaë*

Circa 1553 Oil on canvas 129 × 100 cm Museo del Prado, Madrid

Philip II, son of Charles V, had almost nothing in common with his father save an admiration for Titian. Cruel and superficially religious, Philip indulged his erotic tendencies by commissioning the artist to paint a series of mythological subjects called *poesie*, of which the *Danaë* is a particularly suggestive example. So satisfactory did Philip apparently find this work, that he placed it in his private chamber of voluptas along with Titian's other *poesie*.

56. *Venus and the Organ Player*

Circa 1545 Oil on canvas 136 × 220 cm Museo del Prado, Madrid

Of the many versions of this scene believed to be the work of Titian, the two in the Prado seem the most likely, although there are areas in both that suggest contributions by students in the artist's studio.

(top) Titian, *Man with a Glove*
Titian, *Portrait of a Man* (*The Young Englishman*)

57. *Diana and Actaeon*

Circa 1556–1559　Oil on canvas　190.5 × 207.0 cm　National Gallery of Scotland, Edinburgh

This and the following work (No. 58) belong to the group of *poesie* paintings commissioned by Philip II (see notes for the *Danaë*, No. 55). Titian's penchant for profusion of color and voluptuous form was well applied in these visions of the pagan world.

58. *Diana and Callisto*

Circa 1559–1562　Oil on canvas　182 × 201 cm　National Gallery of Scotland, Edinburgh

59. *Religion Succored by Spain*

Oil on canvas　168 × 168 cm　Museo del Prado, Madrid

This painting, possibly begun as early as 1534 and discarded after the death of Alfonso I, is one of the most important works

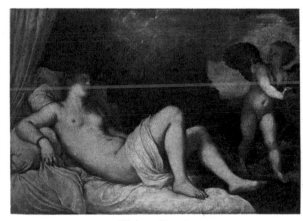

Titian, *Danaë*

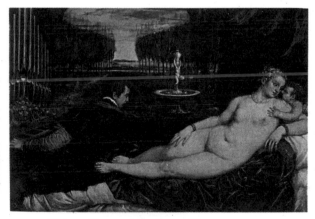

Titian, *Venus and the Organ Player*

of Titian's last period. It is thought that the artist finished it after the victory of the Spanish and Venetian fleets over the Turks at Lepanto in 1571, for it appears to have been inspired by a naval battle. In any case, it was sent to Philip II in 1575.

60. *Pietà*

> 1575? Oil on canvas 352 × 349 cm Galleria dell' Accademia, Venice

Well aware that his life was drawing to a close, Titian offered to paint a *Pietà* for the Franciscan brothers of the Frari church if they would agree to bury him in their chapel. The friars agreed, but Titian did not live to finish the painting. Nevertheless, for its intoxicating, limpid colors and profound mood of sorrow, it is a moving spiritual and artistic last testament.

Tintoretto (*Jacopo Robusti*) (*1518–1594*)

61. *Saint Mark Rescuing a Slave*

> 1548 Oil on cloth 415 × 545 cm Galleria dell' Accademia, Venice

Tintoretto's taste for narrative painting reaches a high point with this powerful work. Figure groupings, color and perspective are interacting compliments to the depiction of the drama.

62. *Christ and the Adultress*

> 1545 Oil on canvas 118 × 168 cm National Gallery, Rome

The spatial complexity prominent in much of Tintoretto's work, especially after 1550, is evident in this dramatically structured narrative painting. The somewhat exaggerated perspective places the figures more in the realm of imagination than reality and emphasizes the luminescent quality of the work.

63. *Christ Washing the Feet of the Apostles* (detail)

> Oil on canvas 210 × 533 cm Museo del Prado, Madrid

Before it found its way to the Prado, this work was a companion piece to the *Last Supper* in the church of San Marcuola in Venice. The expansive spatial quality of *Christ and the*

Titian, *Christ Crowned with Thorns* (*Circa* 1570)

Michelangelo, *Sketch of a Head* →

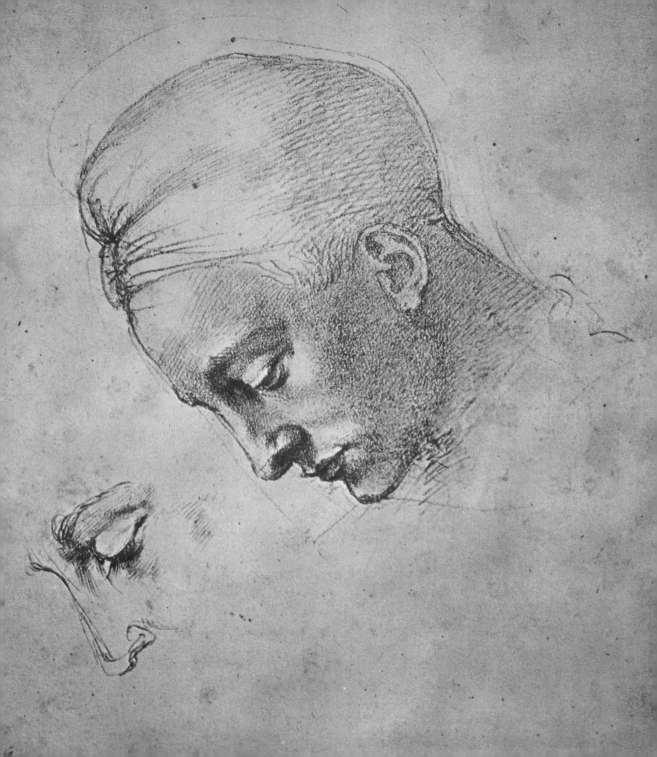

Tintoretto, *Christ Washing the Feet of the Apostles*

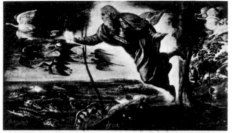

Tintoretto, *The Creation of the Animals*

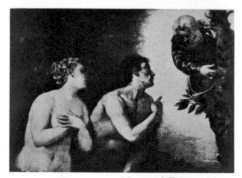

Tintoretto, *Adam and Eve*

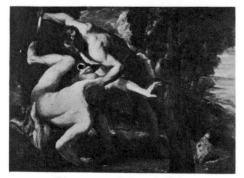

Tintoretto, *Cain and Abel*

Adultress has given way to a sterner, more compact feeling, attributable to the basically horizontal grouping of the apostles and the more frontal perspective.

64. *The Creation of the Animals* (detail)

 1550–1551 Oil on cloth Galleria dell' Accademia, Venice

Along with *Adam and Eve* (No. 65) and *Cain and Abel* (illustration, p. 114), this work belongs to a story cycle from Genesis painted between 1550 and 1553 for the Albergo of the Scuola della Trinità. These works are especially interesting, for they reveal a new sense of nature as colored by the mood of the total composition, and not contemplatively set apart as in the works of Titian—who was, for a time, Tintoretto's master.

65. *Adam and Eve*

 1550–1551 Oil on cloth Galleria dell' Accademia, Venice

66. *Susanna at Her Toilet*

 1555–1560 167.1 × 284.0 cm Louvre, Paris

67. *Susanna and the Elders*

 Circa 1560 Oil on cloth 193 × 243 cm Kunsthistorisches Museum, Vienna

Both *Susanna at Her Toilet* and this work may be understood in light of the series mentioned in the notes for No. 64. The figures are illuminated with crystal clarity, and the details surrounding them are related to a poetic, arcadian background.

68. *The Finding of the Body of Saint Mark*

 Circa 1562–1566 405 × 405 cm Brera Gallery, Milan

69. *The Removal of Saint Marks's Body*

 Circa 1562–1566 421 × 306 cm Galleria dell' Accademia, Venice

Plate Nos. 68 and 69 show two of the paintings, executed for the Scuola di San Marco, that were to depict three miracles of

114

the saint. The incandescence of the lighting and the dramatically receding perspective convey the sense of a miraculous event. The strong chiaroscuro effects intensify the dynamic impact of the action. *Saint Mark Rescuing a Saracen from Shipwreck* (the Accademia, Venice) is the third painting of this group (illustration, p. 115).

70. *Joseph and Potiphar's Wife*

54.0 × 116.9 cm Museo del Prado, Madrid

This work is one of a set of ceiling paintings acquired by Velázquez for the Spanish royal collection. The subtle interaction of color and the graceful, almost balletic movement of the figures are two particularly Venetian mannerist characteristics.

71. *Jacopo Soranzo*

Galleria dell' Accademia, Venice

Soranzo became Venetian Minister of State in 1522 and died in 1551, which would date this work within that period. There is, however, some doubt that it is an original Tintoretto.

72. *The Deposition*

134 × 101 cm Cannes Museum

This painting could be argued as evidence for the theory that Tintoretto made a trip to Rome sometime during the late 1540s. The narrative power owes much to the upward spiral arrangement of the figures—a Michelangelesque feature—and the sculptural use of color.

73. *The Crucifixion* (detail)

1565 5.36 × 12.24 cm Scuola di San Rocco, Venice

Tintoretto, or *Il Furioso* as he was sometimes called for the speed and violence with which he applied paint, was immensely fond of depicting Biblical events. This dramatic scene

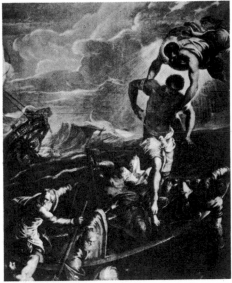

Tintoretto, *Saint Mark Rescuing a Saracen from Shipwreck*. Tintoretto gained a new position of distinction as a result of his three great Saint Mark works.

Tintoretto, *Jacopo Soranzo* (*Circa* 1551). This painting belongs to the Castello Sforzesco Museum in Milan.

is one of several large works he did for the Scuola di San Rocco; it brings an entire wall of the Scuola's dining room to life with its great variety of human activity and emotions, its monumental arrangement of light and color.

74. *Mercury and the Three Graces*

Circa 1578 146.2 × 155.0 cm Ducal Palace, Venice

This is one of a set of four paintings created to decorate a single room in the Ducal Palace. Even in this relatively simple composition Tintoretto achieved the dramatic flow of movement and color that were his trademarks.

75. *The Last Supper*

1591–1594 365.9 × 569.3 cm Church of San Giorgio Maggiore, Venice

Taking advantage of the evening setting for the last meal of Christ and the Apostles, Tintoretto spectacularized the event with dramatically handled light. Note especially the high contrast between light and dark, the ethereal light emissions from the lamp and around Christ's head, and the golden threads with which the artist has drawn the seemingly transparent angels.

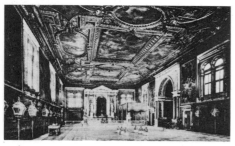

A room on the second floor of the Scuola di San Rocco

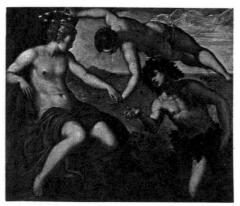

Tintoretto, *Ariadne, Bacchus and Venus* (*Circa* 1578)

(top) The Ducal Palace, Venice →
Interior of the Ducal Palace →
Tintoretto, detail of *Paradiso* (1588) →

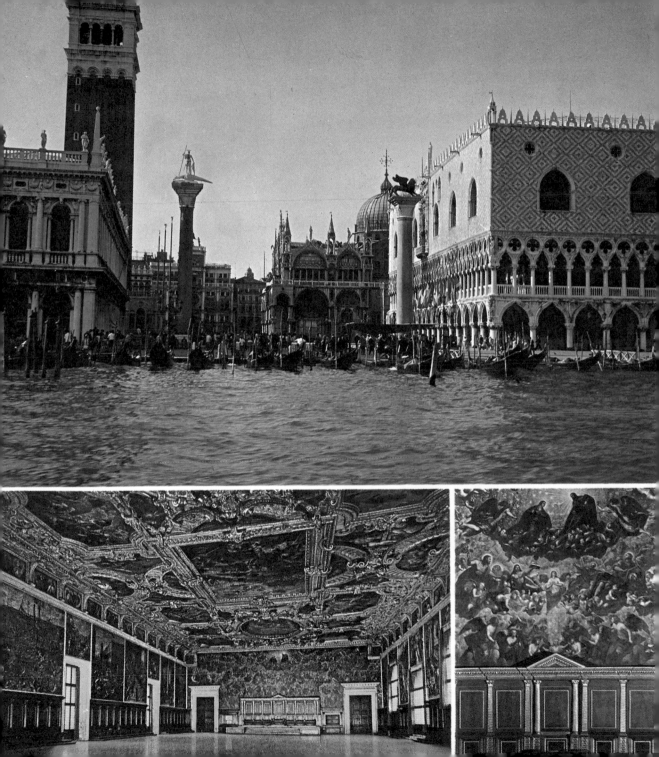

CHRONOLOGY

Florence and Rome	Year	Venice and the Venetian School
Michelangelo born.	1475	
	1478	Giorgione born about this time.
Raphael born.	1483	
	1488	Titian born about this time.
Michelangelo accepted into the school for sculptors established by Lorenzo de' Medici.	1489	
Lorenzo the Magnificent dies.	1492	
Michelangelo goes to Rome for the first time.	1496	
Savonarola burned at the stake in Piazza della Signoria, Florence.	1498	
Michelangelo completes *Pietà* for Saint Peter's. Bramante moves from Milan to Rome.	1499	
Julius II becomes Pope.	1503	
Michelangelo completes *David* in Florence.	1504	
Michelangelo is invited to Rome by Pope Julius II, who commissions him to begin work on papal tomb.	1505	
Michelangelo leaves Rome. Bramante holds cornerstone ceremony for the new Saint Peter's on April 18. Michelangelo and Julius II settle their quarrel.	1506	
Michelangelo begins preliminary work on the Sistine Chapel ceiling. Raphael begins Vatican frescoes in Rome.	1508	Giorgione and Titian work together on decorative frescoes.
	1510	Giorgione dies.
Birth of Giorgio Vasari, mannerist painter, architect of Galleria degli Uffizi, and author of *Lives of the Artists*.	1511	Titian working in Padua on frescoes for the Scuola del Carmine.
Sistine Chapel ceiling frescoes unveiled. Raphael completes frescoes for papal apartments of Pope Julius II.	1512	Titian returns to Venice.
Pope Julius II, patron of Michelangelo, Raphael and Bramante, dies. Succeeded by Leo X, Giovanni de' Medici.	1513	Titian opens studio and begins battle scene for the Great Council Hall.
	1516	Giovanni Bellini dies. Titian becomes first painter of Venice.

	1518	Tintoretto born.
Leonardo da Vinci dies.	1519	
Raphael dies.	1520	
Pope Leo X dies.	1521	
Giulio de' Medici becomes Pope Clement VII.	1523	Titian's wife dies.
Pietro Aretino leaves Rome for Venice, where he becomes lifelong friend of Titian.	1526	
Rome is sacked by forces of Charles V, Holy Roman Emperor.	1527	
	1528	Paolo Caliari, known as Veronese, born.
	1530	Titian works for his patron, Federigo Gonzaga, Marquis of Mantua.
	1532	Charles V becomes patron of Titian.
Michelangelo at work on Medici tombs.	1533	Charles V makes Titian Count Palatine and Knight of the Golden Spur, granting him court entrance and noble rank for his sons.
Michelangelo leaves Florence and sets up permanent residence in Rome.	1534	
Clement VII dies. Alessandro Farnese becomes Pope Paul III.		
Michelangelo completes *The Last Judgment*.	1535	Vasari visits Venice.
Michelangelo completes tomb of Julius II.	1545	Titian called to Vatican, where he is received with splendor. Meets Michelangelo.
	1546	Titian stops in Florence on his way home from Rome.
Michelangelo named chief architect of Saint Peter's.	1547	Titian invited by Charles V to serve as official painter at the Imperial court in Augsburg.
	1548	Tintoretto paints *Saint Mark Rescuing a Slave*, which brings him fame and causes him to be compared to Titian.
Vasari publishes *Lives of the Artists*.	1550	
	1556	Titian's close friend Aretino dies.
Michelangelo dies.	1564	Tintoretto begins monumental paintings for the Scuola di San Rocco.
	1566	Vasari visits Venice, calls on Titian.
	1576	Titian dies.
	1588	Veronese dies.
	1590	Tintoretto's enormous *Paradiso* unveiled. Covers end wall of the Great Council Hall in the Ducal Palace.
	1594	Tintoretto dies.

LIST OF COLOR PLATES

LIST OF ILLUSTRATIONS